IMAGES of America
BREATHITT COUNTY

On the Cover: Members of the Boys Fishing Club gathered at Tommy Howard's Aetna station on Brown Street to prepare for a trip to their favorite fishing spot. This wonderful view of the city of Jackson shows the Breathitt County Courthouse, Slone's Supermarket, the Jaxon Theater, and the Ben Franklin 5 and 10¢ Store on Main Street. (Stephen D. Bowling.)

IMAGES of America
BREATHITT COUNTY

Stephen D. Bowling

Copyright © 2010 by Stephen D. Bowling
ISBN 978-0-7385-8648-9

Published by Arcadia Publishing
Charleston, South Carolina

Printed in the United States of America

Library of Congress Control Number: 2010925347

For all general information, please contact Arcadia Publishing:
Telephone 843-853-2070
Fax 843-853-0044
E-mail sales@arcadiapublishing.com
For customer service and orders:
Toll-Free 1-888-313-2665

Visit us on the Internet at www.arcadiapublishing.com

To Jennifer, Breck, Katie, and Joseph and all my family

Contents

Acknowledgments		6
Introduction		7
1.	Beautiful Breathitt: The Places We Love	9
2.	Proud, Country Faces: The People of Breathitt County	37
3.	For God, Gold, and Country: Religion, Industry, and Service	91
Index		127

ACKNOWLEDGMENTS

Over the years, I have been the fortunate recipient of hundreds of family photographs and images that have been graciously given to me or the Breathitt County Public Library, and this book represents only a small sample of those images. The gracious people of Breathitt County, and even those who no longer call Breathitt County home but still carry it in their hearts, share with me a love of the land, the heritage, the people, and the tremendous history of our county. This book is prepared for them. I wish to say thank you to all those who have shared their family stories, memories, and photographs with me. I sincerely appreciate your love of all things Breathitt.

I also wish to express my appreciation to my staff at the Breathitt County Public Library for their devotion and assistance in helping the library better serve the people of our community. Thank you Susan Pugh, Misty Combs, Tiffany Reynolds, and Ashley Johnson for your support during the production of this work.

This project could not have been accomplished without the loving patience of my children and understanding wife, Jennifer Ann Bowling, who served as one of my editors.

All of the images in this book are used with permission from the personal image collection of Stephen D. Bowling unless otherwise noted.

INTRODUCTION

For more than a century, the county was known as "Bloody Breathitt" because of the thousands of murders and killings that took place in this remote section of the Appalachian foothills. Today things are much quieter, but the legacy of violence still hangs over the hills and hollows of my home.

Breathitt County, located on the Cumberland Plateau of the Appalachian Mountain in the Eastern Coal Field region, was created on April 1, 1839, by an act of legislature and named in honor of Gov. John Breathitt (1832–1834). The 89th county in order of creation, Breathitt County covers an area of 494 square miles and is bordered by Lee, Wolfe, Magoffin, Knott, Perry, and Owsley Counties.

The first county court met at the home of James Little, near the mouth of Cane Creek, where the first magistrates decided to locate the county seat on the large Hays farm near the confluence of the north fork of the Kentucky River and the mouth of Quicksand Creek. Due to a faulty title for the land, the county seat, Breathitt Town, was relocated to a 10-acre area of rolling hill and river bottoms donated by Simon Cockrell.

In 1845, Breathitt Town was chartered by the Kentucky General Assembly and renamed Jackson in honor of Andrew Jackson, the hero of the Battle of New Orleans and president.

Stone and human artifacts uncovered in the county indicate that generations of prehistoric animals and people inhabited the area, leaving behind a rich cultural heritage. Settlers from Virginia and North Carolina first explored the area in the 1770s, but the first permanent settlement was not made until the late 1790s by the Miller, Noble, Neace, Watts, Haddix, Strong, Turner, Back, and Taulbee families.

Most of Breathitt's long history was dominated by periods of quiet subsistence farming by its inhabitants with brief periods of economic development involving the early fir and trapping trades, salt-making trade, the logging industry, and only later by the coal interests.

The violence of the Civil War deeply altered life in Breathitt County, which was divided nearly equally between the Unionists and Confederates. Shootings, thefts, and other actions during the fighting reignited many long-running feuds and economic disagreements.

Known widely as "Bloody Breathitt," the county garnered national attention through a series of the bloodiest feuds in American history as post–Civil War fights ignited the Little–Strong and Hargis–Marcum–Cockrell feuds, among numerous others. On three separate occasions between 1873 and 1910, the Kentucky state militia was deployed in Breathitt County to quell the fighting and to maintain the integrity of the court system.

On July 15, 1891, the Lexington and Eastern Railroad (later the Kentucky Union and the Louisville and Nashville) entered the county, making Jackson the southern terminus. Business boomed, and Breathitt grew and prospered. Seeking the rich cannel coal deposits along Frozen Creek and in neighboring counties, the Ohio and Kentucky Railroad (O&K) was built and operated until 1935.

The prosperity and jobs that came with the railroads brought people to Jackson, and Breathitt's population ballooned from 8,705 in 1890 to 17,540 in 1910. Huge timber tracts brought speculation and investment from lumbermen from across the nation. The largest sawmill in the world operated at Quicksand from the 1890s until 1925 under the Mowbray and Robinson Company brand. E. O. Robinson, owner of the sawmill, later donated 15,000 acres of property at Quicksand and Noble, Kentucky, to the University of Kentucky as the Robinson Agricultural Experiment Substation and Robinson Forest.

Breathitt County today is an important part of the Eastern Kentucky economy, with timber and coal as the primary resources transported across a network of roadways, including Highways 15, 30, and 1110, to all parts of the nation. The largest employers of Breathitt County's estimated population of 16,900 are the Breathitt County school system and the State of Kentucky. Breathitt County continues to grow and is home to three colleges, five high schools, and numerous grade schools and other educational facilities.

This work is intended to give the reader a brief glimpse of only a small sample of the places, people, and events that make up the long and storied history of Breathitt County, Kentucky.

One

BEAUTIFUL BREATHITT
THE PLACES WE LOVE

Breathitt County is a special place filled with remarkable and diverse buildings and some of the finest examples of architecture in the mountains of eastern Kentucky. This chapter is dedicated to those places in the community that residents can still enjoy today and those that exist only in memories.

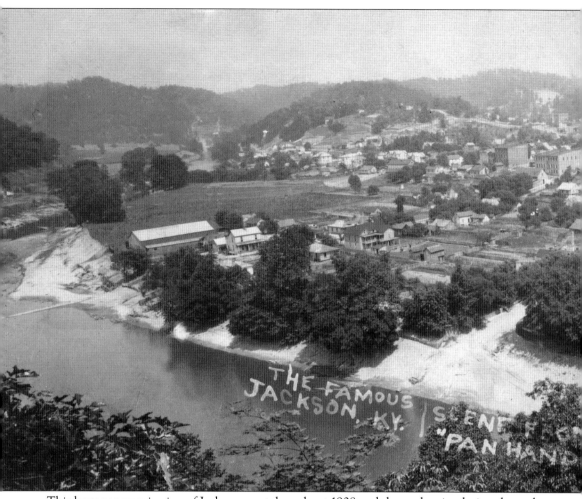

This large panoramic view of Jackson was taken about 1908 and shows the city during the early portion of its heyday. This view shows many of the details that defined the city, particularly the large open bottoms of the Hargis Fields on the left, the courthouse at the center, the South Jackson Bridge and the smoke from the Swann-Day Lumber Company on the right, and the densely populated Frog Pond section of the city in the lower right corner. Nearly every structure in the Frog

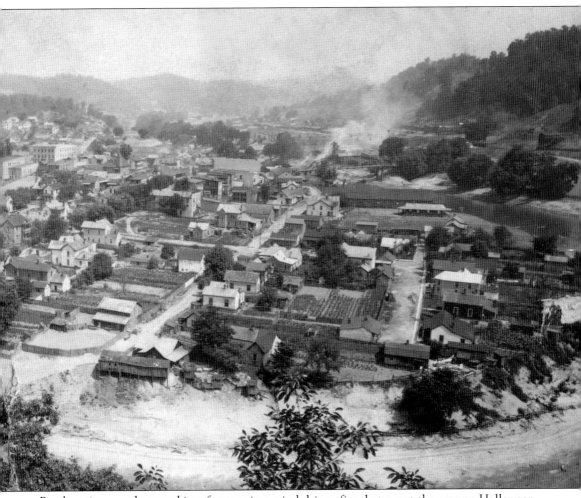

Pond section was destroyed in a fast-moving, wind-driven fire that swept the area on Halloween night in 1913. The fire started in the Thompson Hotel and quickly spread to the neighboring structure. Following the fire, most of Jackson's brick and cast iron facades that survive today were constructed, and the city incorporated a fire department to prevent any future calamities.

In February 1954, Robert Begley and Fred Eversole opened a new funeral home for Jackson in the Watkins building at the corner of Jefferson Avenue (Lees Street) and Highland Avenue. The funeral home became Begley and Gabbard after Bob Gabbard purchased a portion of it. The building was later used as a restaurant and the Lees College bookstore before it was torn down in 2009 to make way for a parking lot that will serve the college and the proposed Jackson Intergenerational Center.

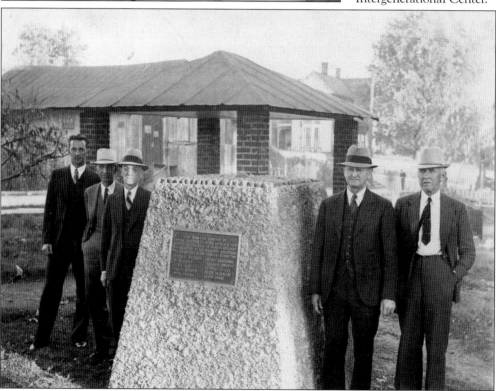

The Breathitt County Chapter of the Sons of the American Revolution (SAR) raised money and erected a monument to all of the known veterans of the American Revolutionary War who settled in what is now Breathitt County. The names were listed on a bronze tablet and placed on a large stone marker that sat on the courthouse square until the new courthouse was constructed in 1963. Members of the SAR who dedicated the memorial were, from left to right, James S. "Penny" Hogg, Ben C. Swell, Herbert W. Spencer, H. June Jett, and Hugh Needham.

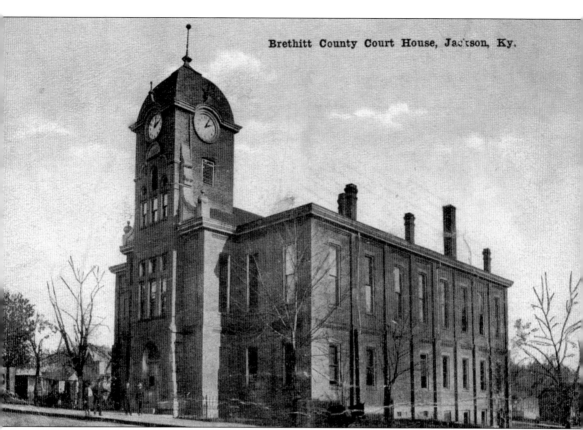

From 1897 until it was razed in 1962, the Breathitt County Courthouse was a symbol of the "Bloody Breathitt" era. In the early 20th century, the courthouse became the center of numerous murder trials during the feud era in the mountains. The most infamous murder in the history of the county occurred outside the door of the courthouse on May 4, 1903, when James B. Marcum was gunned down by Curtis Jett and Thomas White. By the 1950s, the old courthouse was in a neglected state, and officials determined that it could not be saved.

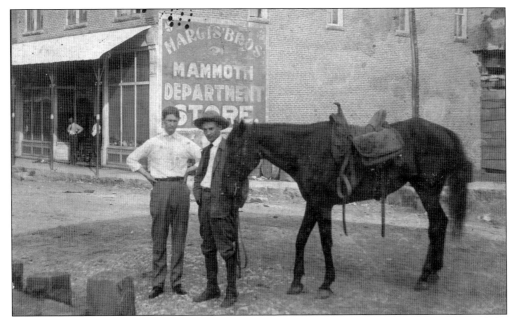

Meredith M. Redwine (left) and a friend show off their horse on Main Street in front of the Breathitt County Courthouse about 1912. Meredith was the son of John S. and Adeline (Combs) Redwine and was a prominent civil leader in Jackson for many years until his death in 1962. In the background, the Hargis Brothers Mammoth Department Store stands on the corner of Main and Court Streets.

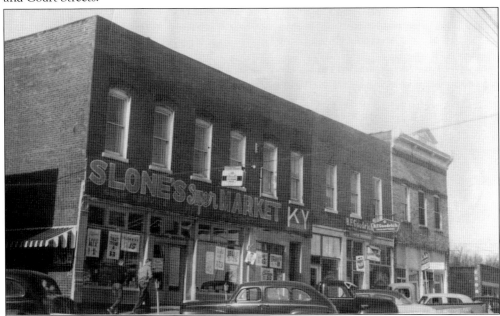

The Day Brothers block, located on Main Street, was the center of business for more than 200 years before the completion of Highway 15 in the mid-1960s. In this photograph from the 1950s, the old Day Brothers Mercantile building was occupied by Slone's grocery store. Farther down Main Street, Stamper's Hardware and Lovins Barber Shop can be seen. The Hargis Bank building at the end of the street is occupied by a haberdashery.

The corner of College (Jockey) Street and Broadway has always been a busy place. Since it was constructed in the 1920s, the brick building that sits at the corner of this intersection has served as a dress shop, gas station, the A. B. Duncan Drugstore, and more recently the offices of the *Jackson Times*. This photograph also shows the old College Inn Restaurant, which was the Stanton dry cleaner for years.

One of the summer social scenes was the old Barclay Stadium on the campus of Lees Junior College in the heart of Jackson. Footraces, baseball, and all manner of enjoyable events were planned and overseen by local recreation director Jimmie Hatton. This photograph, taken in 1953, shows Hatton (right) refereeing a badminton game with a good view of the original Jackson City School in the background.

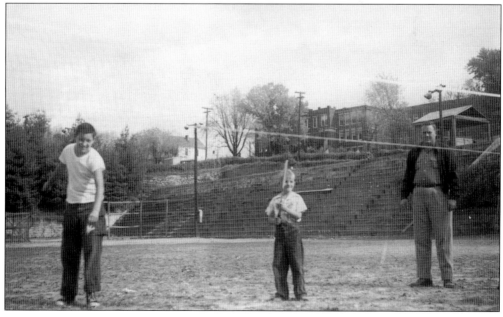

15

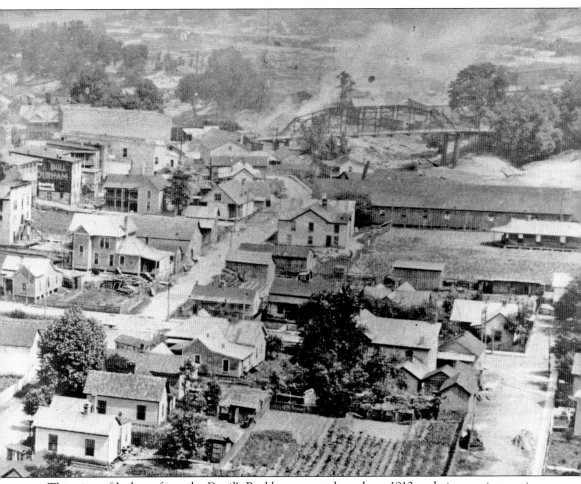

This view of Jackson from the Devil's Backbone was taken about 1912 and gives an interesting view of the Frog Pond section of the city before the streets were paved. The image shows many of the homes and businesses that lined Sycamore, River, and Hawk Streets before the devastating 1913 Halloween Night fire, which destroyed nearly one fourth of the city of Jackson. The white smoke rising from the huge Swann-Day Lumber Company mill in South Jackson can be seen rising above the South Jackson Bridge. The modern bridge was constructed in 1908 and replaced the ferry service that connected Jackson and South Jackson. On the far right in center of the image, the famed Boat House can be seen surrounded by a large fenced yard.

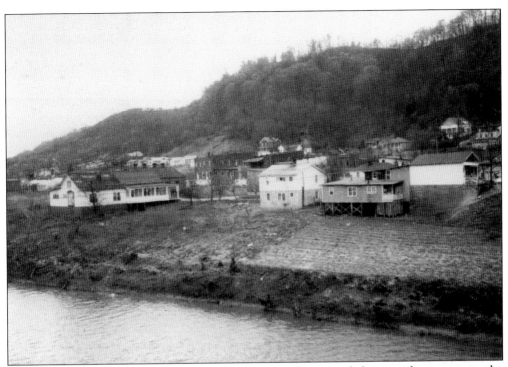

By the 1950s, the sawmills were gone from South Jackson, and the area that was once the economic center of the city was filled with homes. In these two rare views of South Jackson in the 1950s, numerous landmarks are visible. The Combs Cemetery can be seen across the river on Highland Avenue. The vents on the top of the Jackson Ice Plant on Ice (Franklin) Street can be seen in both photographs, and the small store that was known as Sarah Salyers Grocery can be seen. The intersection of Town Hill Road and Armory Drive at the underpass was a busy place for travelers who arrived in Jackson on the Louisville and Nashville (L&N) Railroad. Today the area is known as the Caudill Block, after the mobile homes now parked on the site, and the ice plant and other places now exist only in these photographs.

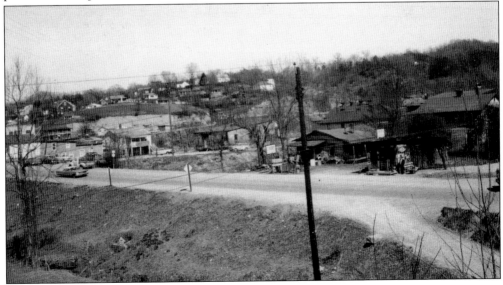

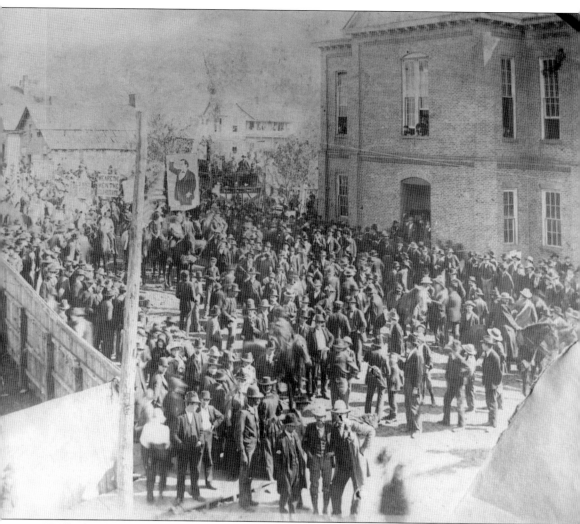

"Will it be silver or gold?" was the question during this 1896 Democratic party rally on Main Street that featured support for the "gold bugs" and presidential candidate William Jennings Bryan. The speaker for the day was William Goebel, a prominent Democrat from Newport, Kentucky, who was running for the office of governor of Kentucky. Both William Jennings Bryan and Goebel were defeated by Republican candidates. By an act of the Kentucky Legislature, Goebel was declared the winner of a disputed election in 1900. He was shot on his way to the capitol to be sworn into office and died three days later. He was administered the oath of office on his deathbed and remains the only governor in American history to die as the result of an assassin's bullet. This excellent view of Main Street shows the Breathitt County Courthouse as it appeared before the large bell tower was added to the front entrance of the building. Judge James Hargis and Sheriff Edward "Ned" Callahan can be seen standing in the doorway of the courthouse.

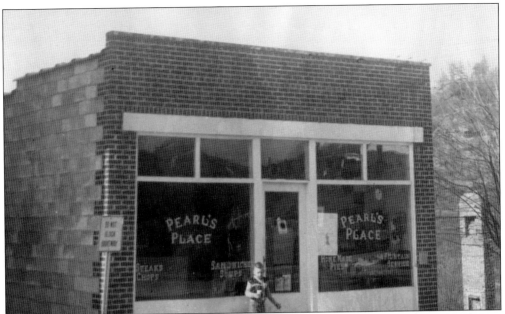

Pearl's Place opened on Main Street and focused on drawing the younger crowd to the hamburger joint. Pearl's Place offered specials for Jackson City and Breathitt High School students who came up town for lunch. It later became the Scooby Doo Restaurant and has since housed numerous businesses. After the building was purchased by the Breathitt County Fiscal Court, the Breathitt County Coroner's Office occupied this small building on Hargis Lane.

Double-pinned dogtrot cabins filled the hills and hollows of Breathitt County until the middle part of the 20th century. Hundreds of families called these cozy structures home, like these unidentified family members who were living near Elkatawa when they were photographed by Christian missionary Dortha Wilson during her trip to Breathitt County in 1927. (Courtesy of the Breathitt County Public Library [BCPL].)

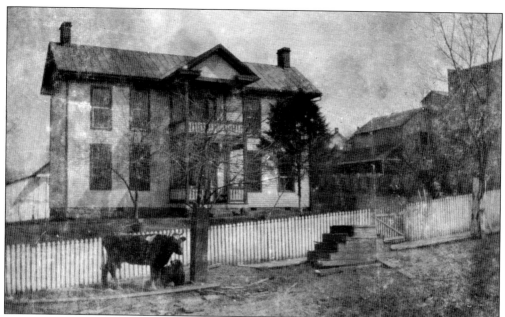

James H. and Louellen (Day) Hargis constructed this home on Court Street near the Arlington Hotel where they raised their two children, Beech and Evelyn (Hargis) Hogg. The home was also the site of Judge Hargis's wake in 1908 after he was shot and killed by his son, Beech Hargis. The Hargis house was razed to make way for the construction of Breathitt High School in 1937.

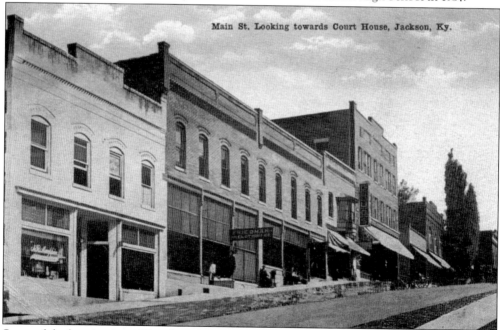

Some of the best images of Breathitt County were captured by A. S. Sizemore and published in his series of postcards. This Sizemore image shows the buildings on Main Street looking toward the Breathitt County Courthouse from Broadway. This section of Main Street was home to Mauppins Department Store, Friedman Clothing Company, the Jackson Drug Company, and, farther up the street, H. June Jett's Haberdashery.

Snake Valley, as seen in this A. S. Sizemore postcard image, was the name give to the large, open valley that extended up the North Fork of the Kentucky River from Jackson to the Quicksand community. The valley was home to numerous blind tigers and other illegal bootleg joints that catered to the alcohol-consuming members of the community. Numerous fights, stabbings, and murders in Snake Valley helped give Breathitt County its "bloody" name.

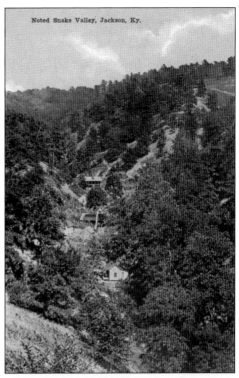

The famous switchback curve on old Highway 15 winds its way down Frozen Hill across the mountain to the open valleys of Cope Fork of Frozen Creek. The road was once one of the three main routes into and out of the city of Jackson but was the most dangerous stretch of highway on the old Lexington Road. Frozen Hill was the scene of numerous accidents, including several fatalities.

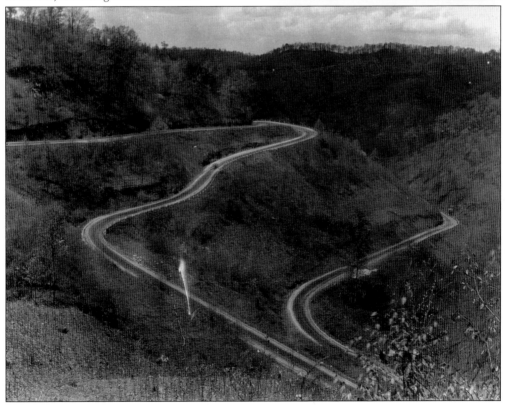

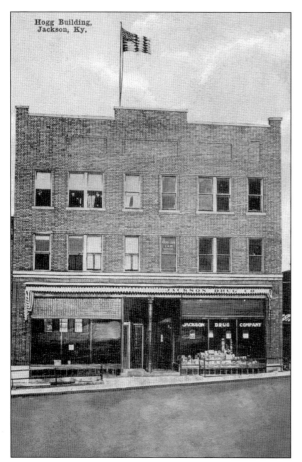

Hogg Building, Jackson, Ky.

The Hogg Building was constructed by new pharmacist William Pryce Hogg with help from James H. Hargis, his father-in-law, shortly after Hogg graduated from pharmacy school. The building was spared destruction but did receive some minor damage during the 1913 Halloween fire. The building was the scene of numerous dances in the third-floor dance hall, which doubled for some time as the home of the Breathitt Masonic Lodge No. 649.

One of the most famous scenes of Jackson was this widely reproduced postcard view taken about 1904 from the Combs Street section of South Jackson when it was still known as Inverness. The hand-tinted view shows the growth of Jackson since the arrival of the Lexington and Eastern (L&E) Railroad in 1891. Much of the development of Jackson as the early economic capital of the eastern section of the state was due to the convergence of the Kentucky River and the L&E Railroad.

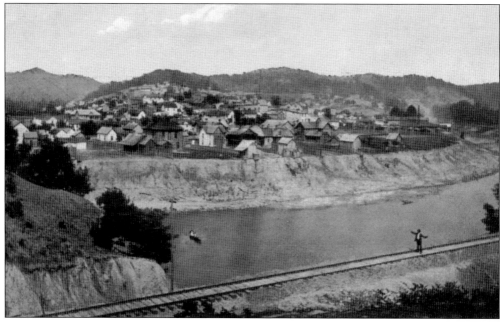

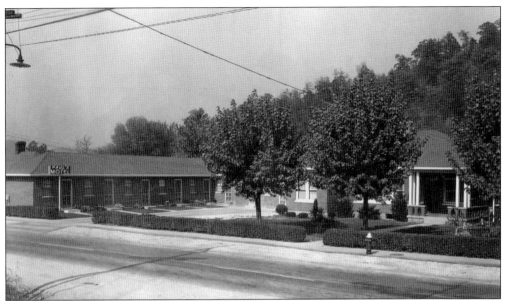

Located on Lower Main Street, Paul's Motel has always been a regular fixture for travelers on old Highway 15. Located near the Sue B. Elliott Addition of the city of Jackson, Paul's Motel was conveniently located on the main drag and featured simple accommodations and a very reasonable rate. The motel has changed a great deal under the ownership of Freeman Bach, but Paul's Motel still serves thousands of travelers each year.

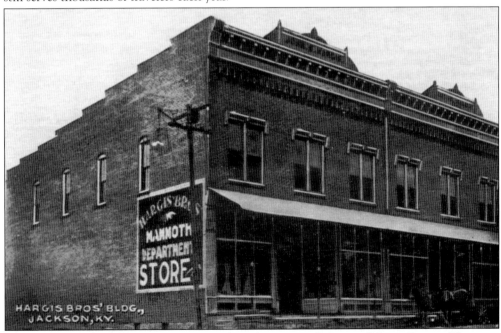

The Hargis Brothers mercantile was located on the corner of Main and Court Streets. The main storehouse building and feed buildings that stood on the hillside behind it represented the largest commercial establishment in eastern Kentucky before the death of Judge James Hargis in 1908. The building was destroyed by fire in 1927, and the Citizens Bank and Trust Company building now occupies this site.

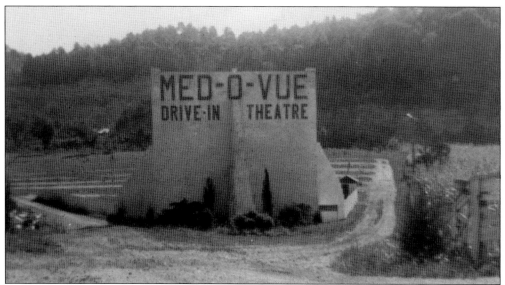

This rare view shows the Med-O-Vue Drive-In Theatre on Quicksand Road near the Dumont community, a popular hangout spot. Showing the newest movies, the Med-O-Vue was complete with a full-service concession stand, in-car speakers, and a theater sitting area from which moviegoers could see the screen. The drive-in was sold and changed its name to the Jaxon Drive-In before it closed in the early 1980s.

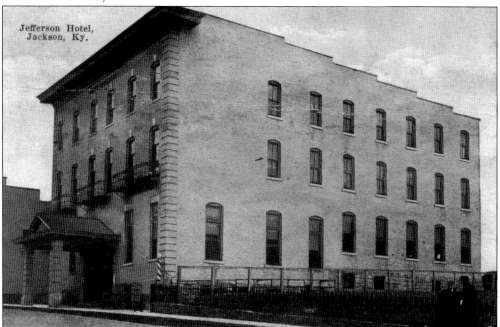

The Hotel Jefferson Company was incorporated on September 25, 1912, by several prominent local businessmen, including Mitchell Crain, Charles J. and Armina Little, John Hindman, M. P. Davis, and Stephen Crawford, with the purpose of constructing a "top class hotel in the European model," according to their advertisements. The hotel changed hands numerous times over the years before closing in the 1960s. The building fell into disrepair before it was remodeled to become the Breathitt County Life Skills Center in 1998.

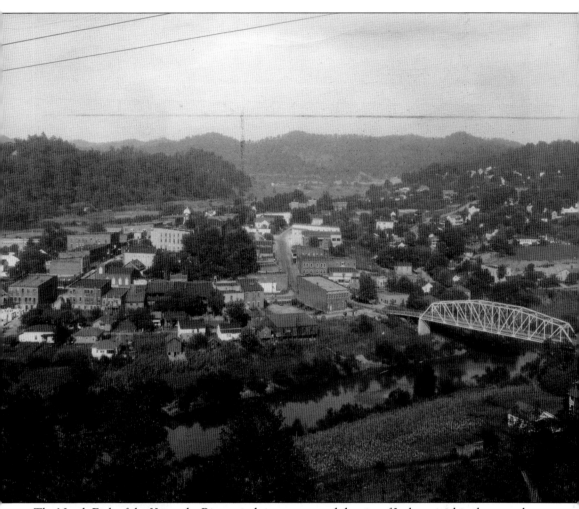

The North Fork of the Kentucky River winds its way around the city of Jackson in this photograph taken in 1953, when the entire population of Jackson was 1,980 people. The bell tower of the Breathitt County Courthouse can be seen in the center, and the undeveloped Jett farm on the Panbowl can be seen at the top of the photograph. Many Breathitt County residents remember Jackson during those days, when it was still just a small hometown. The construction of Highway 15 and numerous fires totally transformed the look of the small town. Today few of these original buildings remain in the city of Jackson.

A fast-moving fire, which started under a set of steps, raced through this small cabin on the campus of the Little's Creek Mission and Children's Home during the early morning hours of December 8, 1949. Despite the best efforts of mission staffer Dessie Scott, nine children were unable to escape the flames. The next morning, the charred remains of nine children were found in the ashes. Miss Scott died the next day at the Bach Memorial Hospital on Main Street in Jackson. The home was later moved to Pine Ridge in Wolfe County, and the mission school was renamed the Dessie Scott Children's Home.

The campus of the Little's Creek Mission and Children's Home had grown to nearly 20 buildings before the tragic 1949 fire took the lives of nine children. This view, taken from the steep hillside behind the main dormitory building, shows the main buildings of the campus. Hundreds of children and families were served by the efforts of founders Fred and Esther Pushee.

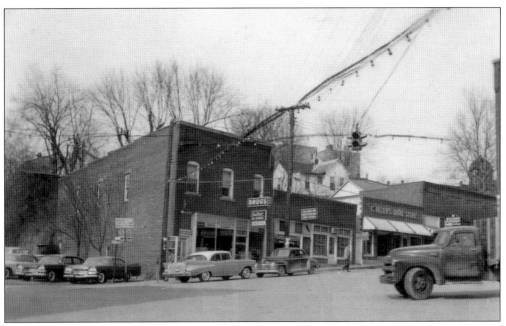

The intersection of College Avenue and Broadway was always a busy place due to its location near the only bridge that connected Jackson and South Jackson. At this intersection were the Crain Brothers' Mercantile, A. B. Duncan's Drugstore, the Stacy Hotel, numerous restaurants, and many other businesses. Every train passenger who wanted to do business in the downtown district had to pass through this intersection.

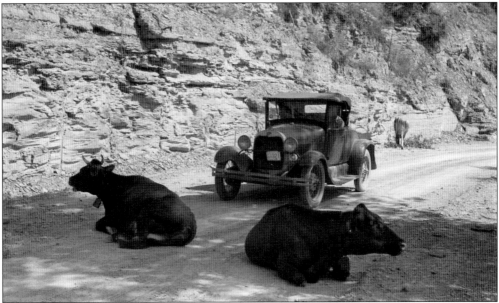

Cattle and other livestock were a constant issue for drivers in Breathitt County. In this photograph by Marion Post Wolcott from the 1930s, a driver on Frozen Creek was forced to exit his car and run these cattle out of the road before the trip to Jackson could be completed. Wolcott chronicled hundreds of Breathitt County scenes with her camera during the late 1930s and early 1940s. (Courtesy of the Library of Congress.)

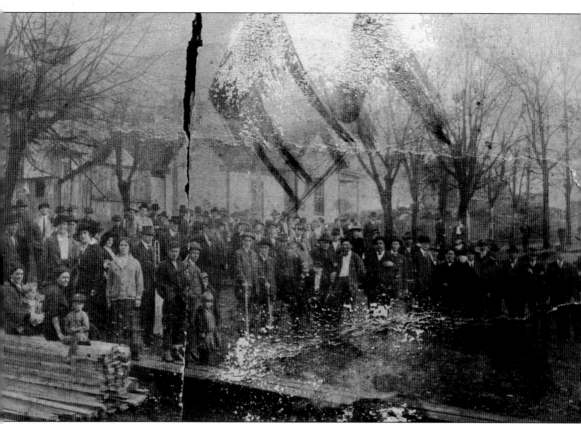

At 2:00 p.m. on the afternoon of Monday, November 30, 1914, a large crowd gathered at the government lot to officially break ground on the federal building project. Jackson mayor Lewis Hays presided over the ground-breaking before a crowd that the *Jackson Times* reported consisted of "a hundred men and women, 14 cows, one dog, a photographer, three lawyers, two doctors, and some children." Following some martial music by a rented band from the Zarlington Comedy Club from Lexington, Mayor Hays and several guests spoke before Mayor Hays turned a shovelful of dirt to officially begin the project. The U.S. government awarded the construction contract to J. D. Rogers and Company from Moorestown, New Jersey, and Arthur Johnson of Princeton, New Jersey, was appointed supervisor of the construction. In the coming months, frequent rain and difficulty obtaining the marble needed for the building delayed the work, and the first court sessions were delayed until 1916, when it was completed at a cost of $100,000.

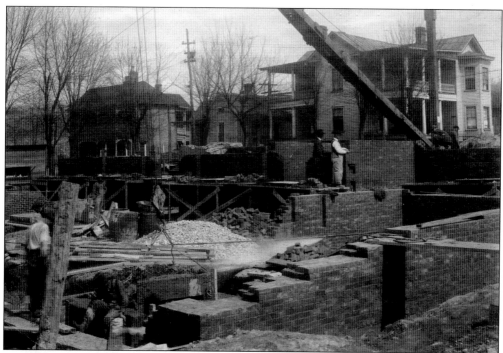

The Jackson Federal Building is one of the most recognizable structures in the city of Jackson. Construction was started in 1915, and the building was occupied in 1916 and was home to the local office of the FBI, Secret Service, the Department of Revenue, and the Jackson Post Office. On the upper floors, the federal court system operated until the 1970s. After the closing of the federal court, the Jackson Post Office continued to occupy the building until 1986. The Breathitt County Health Department called the federal building home from 1986 until 2009.

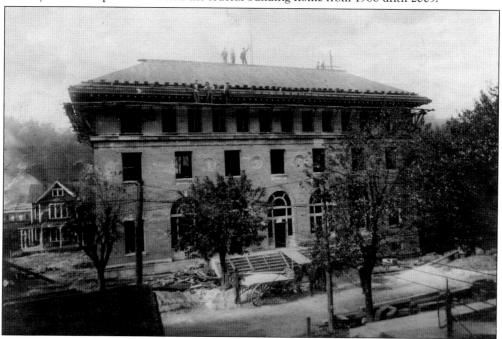

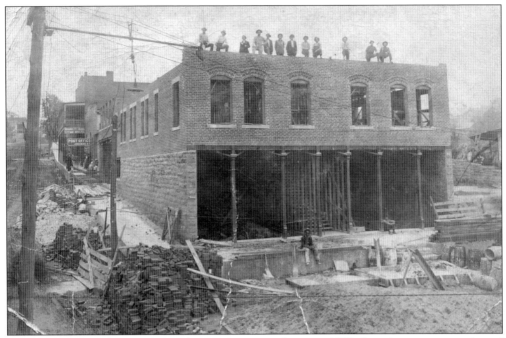

The construction of the Stacy Hotel was nearing completion in 1915 when this image was taken of the new building at the corner of College Avenue and Broadway. Adam Stacy and John Redwine built the structure with the intention of operating the Redwine Inn on the top two floors. After the building was completed, the Stacy Hotel opened with complete service, including heating grates in each of its 27 furnished rooms.

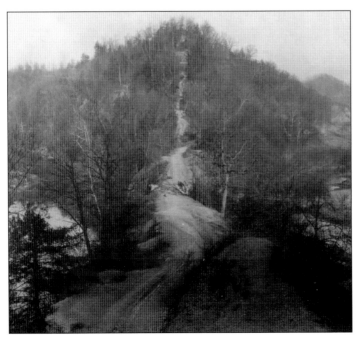

Stripped of its railroad tracks, the Devil's Backbone was a long stretch of dirt and jagged sandstone outcrops that led to the open fields of the area known as the Panbowl. This narrow strip of land created by a natural oxbow was also known as the Panhandle. This geological feature was created when the North Fork of the Kentucky River made a 4-mile swing around the Miller farm and returned to within 66 feet of the other side of the river at the site now called the Cut Through.

Not long after this image of the courthouse bell tower was taken in 1960, a wrecking ball demolished the structure to make way for the current Breathitt County Courthouse, which was constructed in 1963. The bell tower featured a clock on each of its four faces, and residents joked that the clocks were always correct at least twice every day. Several of the clock faces were saved from the demolition and still exist in Breathitt County today.

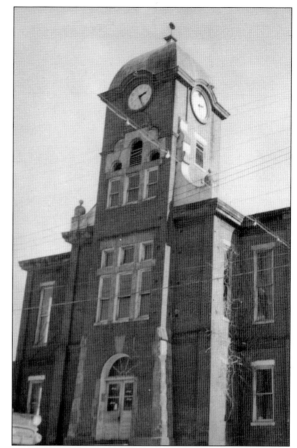

The Panhandle Mill can be seen in the lower left corner of this image of Jackson from about 1907. The image, taken from the top of the Devil's Backbone, shows an excellent view of the old gristmill, the timber boom stretched across the river, and the large sandbar at the end of Court Street.

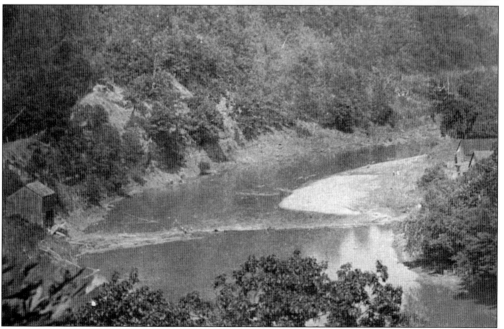

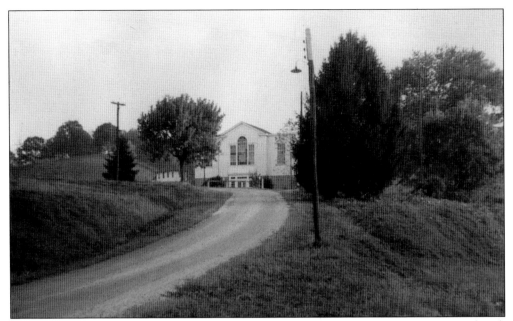

In 1940, the University of Kentucky and the Works Progress Administration (WPA) started work on the State Experiment Station Auditorium on the campus of the Quicksand substation. Over the years, the auditorium has housed 4-H competitions, family reunions, spelling bees, and thousands of other community events. The building is still in use today, a testament to the construction techniques used by the WPA in hundreds of Breathitt County buildings.

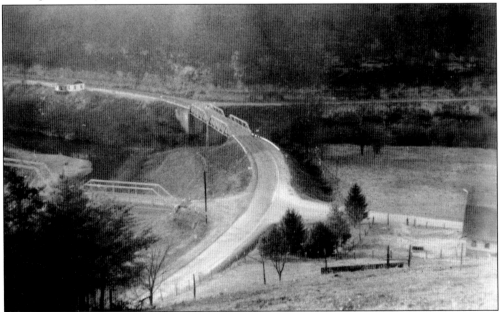

Quicksand Creek (right) empties into the North Fork of the Kentucky River at the community of Quicksand. The area around the community of Quicksand was the scene of the annual Harvest Festival at the Robinson Experimental Substation. Today this area has changed a great deal due to the construction of Highway 15 and the painting of the distinctive blue bridge that now leads across the North Fork to the community of Quicksand.

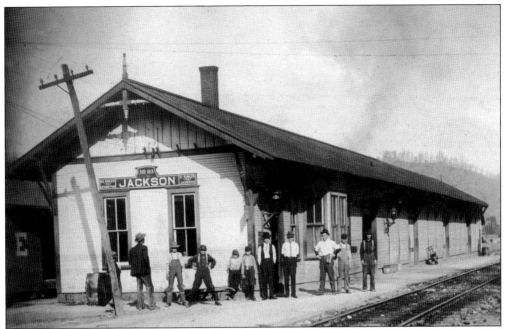

The L&E Railroad cut through the foothills of the Cumberland Plateau on its way to Jackson. This view shows the freight and passenger depot at Jackson as it appeared about 1910. The L&E was purchased by the Louisville and Nashville Railroad, which tore down this station and constructed a permanent brick structure in the 1920s.

Royal Crown (RC) Bottling Company moved to its new location on lower Main Street in the early 1950s. The RC trucks covered eastern Kentucky as they delivered RC, Nehi, and various other brands of soft drinks to nearly every community. Royal Crown replaced the oldest soda drink manufacturer, the Jackson Bottling Works, which had produced Star Cola for the people of Jackson and the surrounding areas for years.

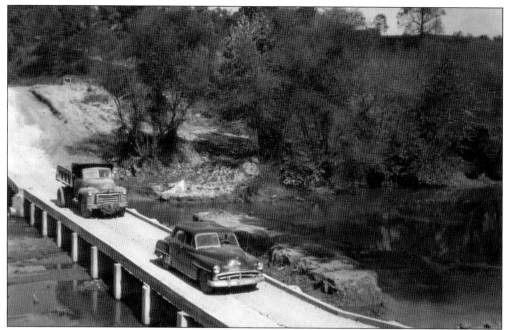

For the people of War Creek and Lawson, the old Mount Carmel low-water bridge was the primary means of accessing their community. The frequent high waters and flooding would cover the bridge and force local residents to travel nearly an hour out of their way to get to Jackson. To the relief of many, the low-water bridge was replaced by the Martha L. Collins Bridge.

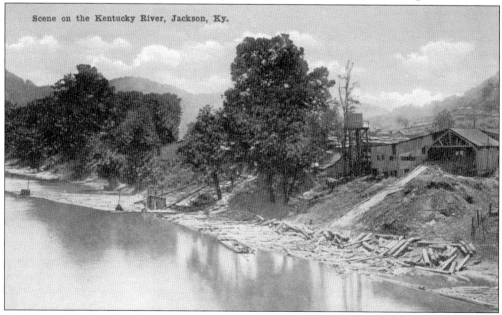

The Swann-Day Lumber Company operated a large lumber and planing mill in South Jackson during the early days of the timber boom in Breathitt County. Large hooks caught the logs as they floated down river, and then a steam-powered hoist dragged the oak, walnut, and poplar logs up the river bank to the circular saw, where they were turned into veneer that was shipped around the world.

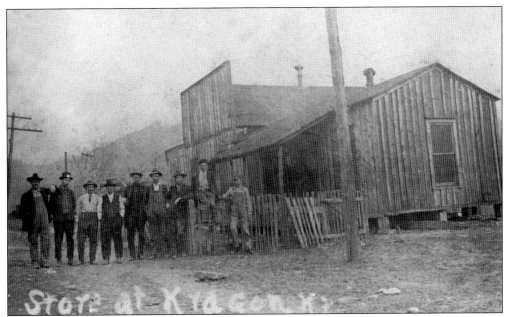

The Olean Chemical Company at the mouth of Big Branch and Stillhouse Branch at Kragon was owned and operated by David and Robert Hancock of Olean, New York. The large operation included the Olean Chemical Company storehouse (seen above), a large row of company houses, and a movie theater. Until 1932, the Olean Chemical Company employed hundreds of Breathitt County residents in the production of charcoal, alcohol, and acetate of lime.

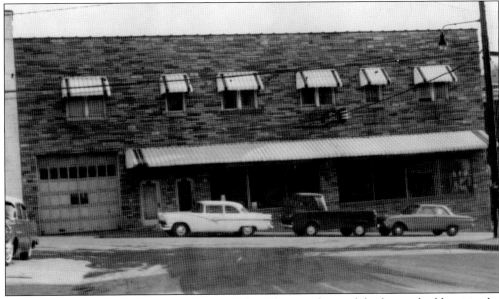

William H. "Red" Reynolds sold Ford cars and trucks out of one of the largest buildings in the city of Jackson for many years. The Ford Garage, located on College Avenue, was the scene of numerous community events and dances before it closed. By 1960, the Kentucky Department of Transportation entered negotiations to purchase the building to convert it into the District Highway Office, but they later purchased property for construction on Highway 15. Since 1968, the Reynolds Building has been home to the Breathitt County Public Library.

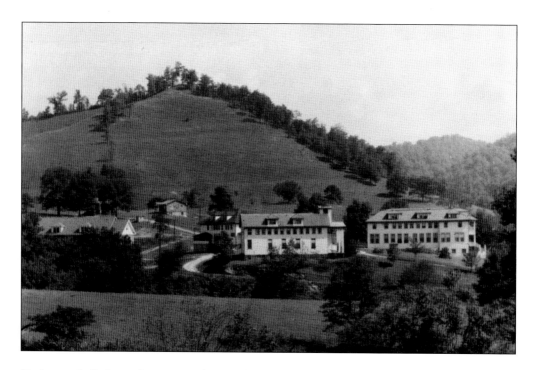

High on a hill above the river at the mouth of Mill Creek, the Kentucky Mountain Holiness Association operates the Mount Carmel School and campus on nearly 350 acres in the Lawson community. Founded in 1925 by Dr. Lela G. McConnell, the campus boasts a grade school, high school, and a Bible college founded in 1931, and in 1948, the school added WMTC, a 1,000-watt station.

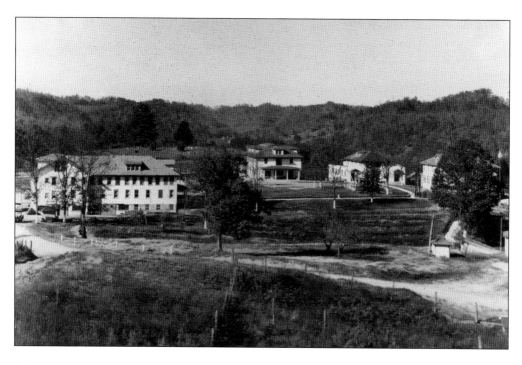

Two

Proud, Country Faces
The People of Breathitt County

For centuries, the people of the mountains of Breathitt County have endured through hope, tragedy, celebration, devastation, and joy. The true strength of the community rests in the enduring spirit and the proud faces of the people who call Breathitt County home. To these people, in whom the mountain spirit still lives, chapter two is dedicated.

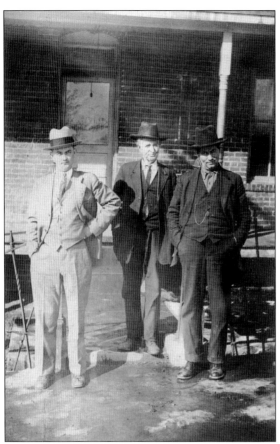

Three political powerhouses stood for this photograph in 1938, at the peak of their power. From left to right, Breathitt County sheriff Lee Combs, Breathitt County judge Pearl Campbell, and political boss Solomon L. Combs stand on the steps of the county jail shortly after their Hogback coalition party swept away control of county offices in the hotly contested 1937 elections. Within the year, Sheriff Lee Combs was the victim of an assassin's bullet.

McCager "M. C." and Sarah (Arrowood) Turner lived their entire lives within a mile of the places where they were born, married, raised their children, and are buried. The children of two Union veterans of the Civil War, McCager and Sarah Turner married in 1892 and raised eight of their nine children (the ninth died) before her death on August 13, 1932. McCager died in 1962, and they rest today in the Arrowood Cemetery at Canoe.

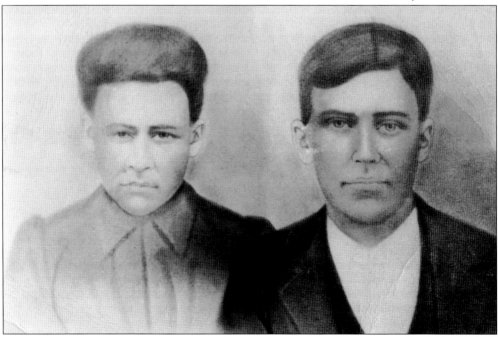

A new book was a precious commodity for most of the children in Breathitt County, and many had their desire to explore the world through literature satisfied by a visit to the local bookmobile. By the mid-1950s, Breathitt County was serviced by two bookmobiles that crossed the county to deliver books and educational supplies to children from Turner's Creek to Evanston as part of the Kentucky bookmobile program. Driver Oakley Turner was known for his trips around the county to bring reading materials to children and adults as part of the program. New books and classics were restocked frequently on the bookmobile as the result of donations during the annual book drive conducted by children in Breathitt County who went from door to door, collecting books. The bookmobile program continued until the late 1990s.

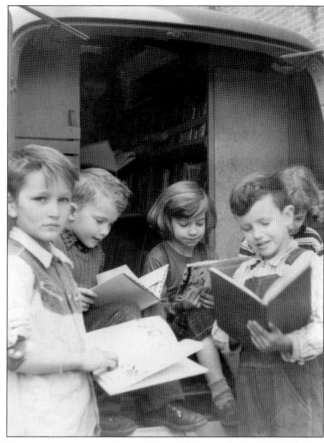

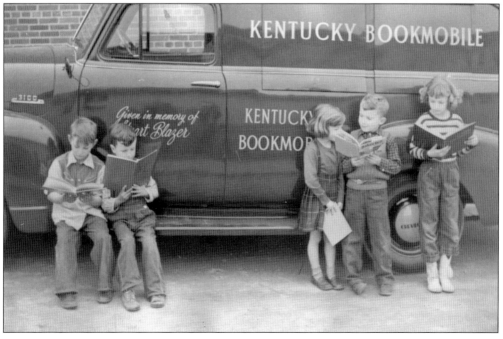

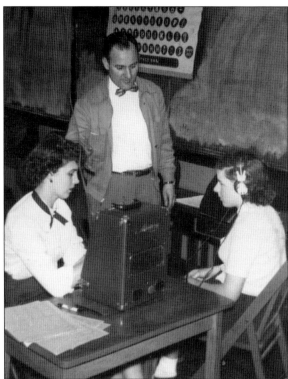

Health fairs were a common happening across Breathitt County as local health department officials traveled the community in the 1950s and 1960s. During one of those fairs, Mrs. Lewis Napier uses an audiometer to test the hearing of a Breathitt High School student while Breathitt County Health Department administrator J. Gordon Combs helps administer the hearing exam. (Courtesy of the BCPL.)

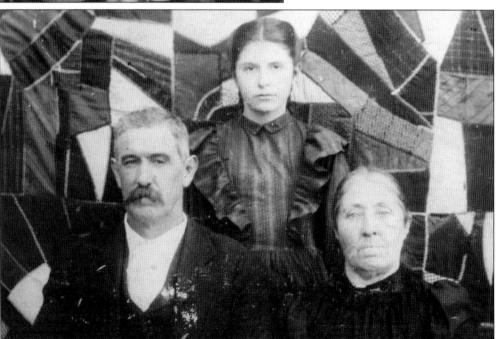

This photograph of Henry D. and Rebecca Back was taken by their son, Claude Duval Back. Henry, known primarily by his nickname "Snoot," owned a large and beautiful farm on Quicksand Creek and frequently hosted large family gatherings with his eight children. Their granddaughter, Maudie Back, stands behind her grandparents in this image from about 1907.

James Carl Back was partially through his second term as sheriff of Breathitt County when he suffered a massive heart attack and died on March 18, 1962. The son of William D. and Emma Back, Carl was a very popular Democrat and loved to talk to the people who came to the courthouse each day. Hundreds of weeping friends and family members filled the Van Meter Gym at Lees College for his funeral.

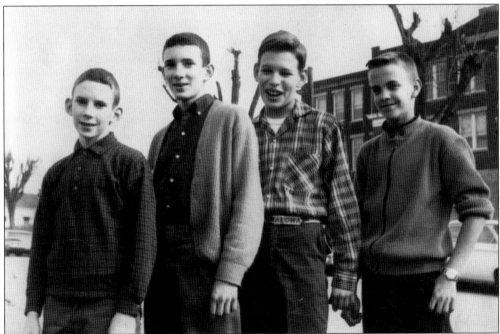

From left to right are Harold Douthitt, Martin Douthitt, David Collier, and Hillard Smith, who were among a group of Boys Scouts chosen to attend the 50th Annual Boy Scout National Jamboree in Colorado Springs, Colorado, in 1960. The four students from Breathitt County represented Troop 91 and joined approximately 55,000 others at the national event. (Courtesy of the BCPL.)

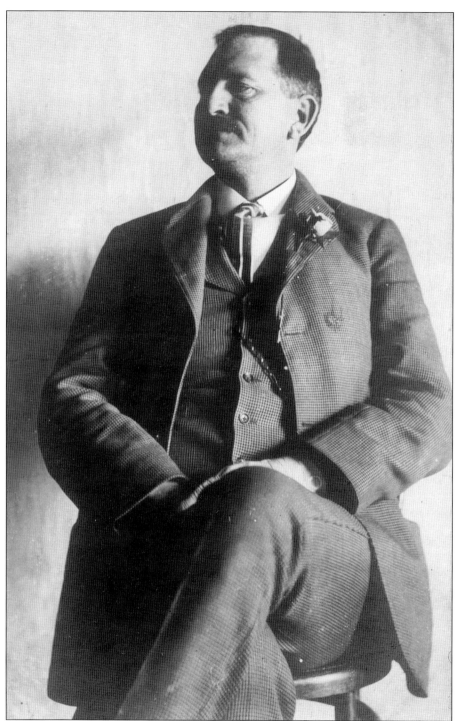

The most powerful man in the history of Breathitt County assumes a casual pose in this 1907 postcard image of famed feudist James Henderson Hargis. Hargis ran the political and economic machinery that controlled much of Breathitt County with an iron fist from his rise to power in 1891 until he was shot and killed by own his son, Beech Hargis, on February 6, 1908.

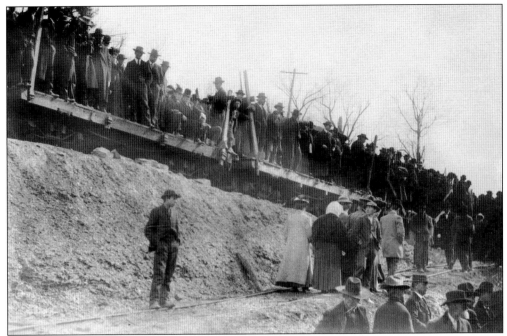

The tragic death and funeral of James H. Hargis was a shock to most people of the area at that time. Hargis was shot and killed on February 6, 1908, in the Hargis Mercantile on Main Street, not by his many political and feudal enemies but by his son, Beech Hargis. Train cars and flatbeds filled with thousands of mourners accompanied Judge Hargis's body to its final resting place on February 8, 1908.

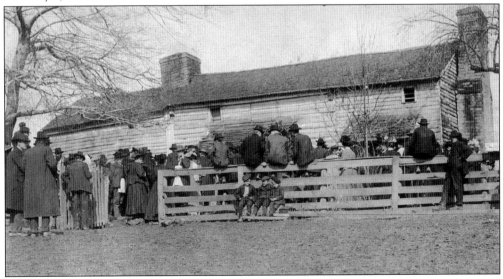

The Stephen Miller–John Hargis house was a large, double-pin dogtrot cabin near where LBJ Elementary School now sits. In 1908, more than 500 people attended the funeral of fabled feud leader Judge James H. Hargis after he was shot and killed by his son, Beech Hargis. Mourners from across the area and state filled the house and yard that sunny February day to say farewell to the most powerful man in Breathitt County for most of the late 19th and early 20th centuries. Hargis was later buried a few short yards from the John Hargis home.

Abraham Hunter Short was born in 1854 to Civil War veteran Andrew Short and his wife, Mary (Terry) Short. A prominent businessman and civic leader in Jackson, Hunter was well known and respected by his peers. In 1891, he was a member of the original petitioning delegation that traveled to Louisville and secured the chartering of Breathitt Masonic Lodge No. 649. He died in 1935 at the age of 80. The clear blue eyes of Ana Eliza (Cardwell) Short can still be seen despite the black and white nature of this wonderful photograph of her. She was the daughter of Thomas P. and Ellen (South) Cardwell and married Abraham Hunter Short in 1876. The couple had 12 children.

Most of the African Americans in the city of Jackson settled and lived in a section of Jackson named for one of its longtime residents, Charles Breckinridge "Buck" Wilson. Buck Wilson lived on Buck Hill or Ewe Hill on Hurst Lane and was widely known for his expert stone masonry and his work at the Jackson Stone Quarry on Highland Avenue. Buck died in March 21, 1931, and was buried in the Strong Cemetery on Marcum Heights.

In the early 1960s, Mrs. Tommy Howard served as safety chairman of the Jackson Woman's Club and helped organize the Jackson Safety Patrol, a cooperative group who learned to avoid accidents and helped organize safe opportunities for recreation in the city. Members of the safety patrol proudly wear their badges as they direct traffic near Jackson City School on Highland Avenue.

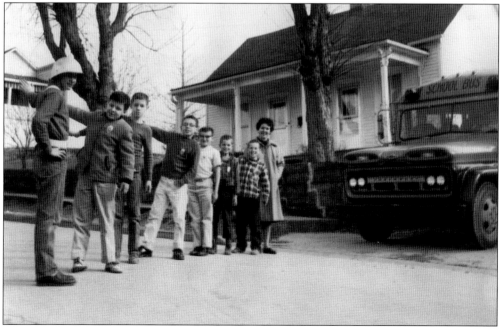

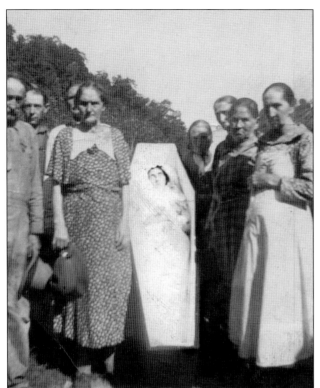

In accordance with mountain tradition, the family gathered around the casket of Nancy (Neace) White for one last photograph together. Nancy was the daughter of Jacob and Polly (Francis) Neace and was married for more than 38 years at the time of her death. After the photograph was taken, the family buried her in the White Family Cemetery on River Caney.

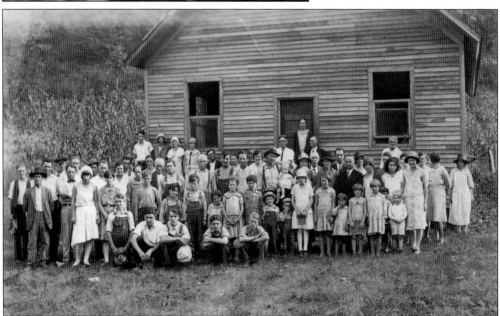

When the Breathitt County school system constructed more than 100 one-room schools across the county, it did not anticipate the use that these public facilities would get through the years. These simple one-roomed structures, like this one near Athol, in most instances became the centers of the community and were the scenes of weddings, funerals, political rallies, meetings, religious services, and occasionally school.

Arthur Haddix and his wife, Maude (Noble) Haddix, stand at their Lost Creek home. Arthur was the son of William W. and Orlena (Deaton) Haddix. In 1913, he married Maude Noble, the 21-year-old daughter of James B. and Margaret (Campbell) Noble. They raised eight children together until Maude's death in 1939. Arthur remarried to Beatrice Tharp in 1945, and they had one son. Arthur Haddix died in Fayette County on May 18, 1974.

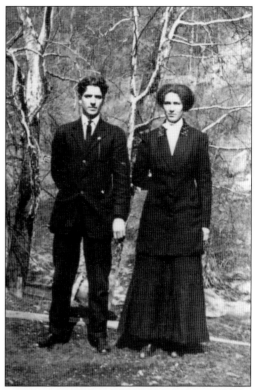

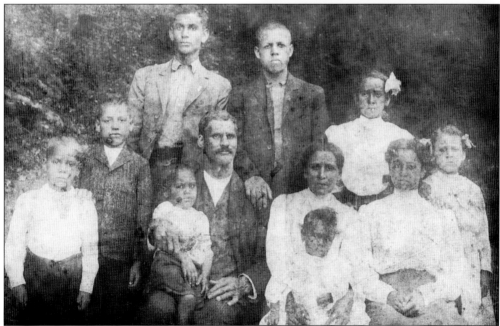

One of the largest and most prominent African American families in Breathitt County was the Harry and Matilda J. (Hargis) Spicer family of Ewe Hill in Jackson. The large family included 10 children: Leander, Evie, Dellie, Golden, Mescie, Carlis, Eli, Mary, Susan, and Harlan, nine of whom are shown in this family portrait.

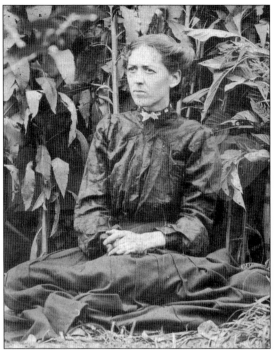

Mary E. Wilson was better known as "Granny" Wilson during the 102 years that she lived in Breathitt County. The daughter of Margaret "Peggy" Wilson and her slave master, James Lewis Moore, Granny Mary raised her children near the intersection of Highland Avenue and Hurst Lane and died on May 26, 1974.

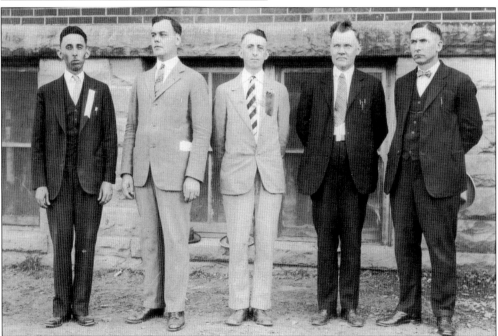

Some of the most prominent educators in the mountains gathered in Whitesburg in 1926 for the annual UKREA (Upper Kentucky River Education Association) Teachers Association Meeting. Featured are, from left to right, Superintendent Arlie Boggs of Letcher County, Breathitt Countian Fallen Campbell from the Eastern State Normal College, Ervine Turner from Breathitt County, Superintendent M. C. Napier of Perry County, and Superintendent Hirow Taylor of Knott County.

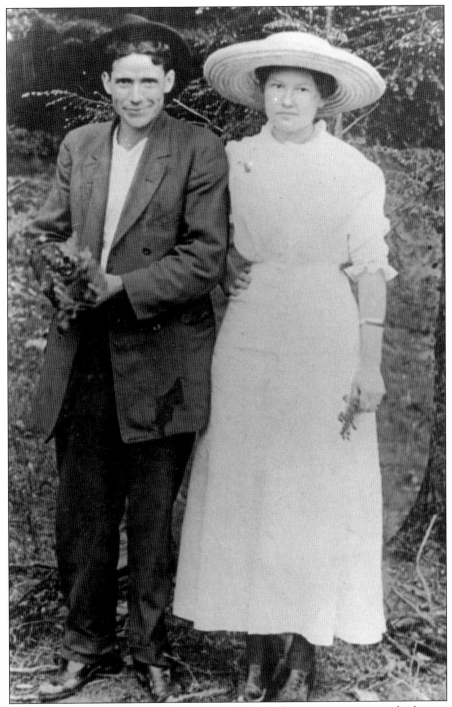

On June 29, 1935, William Penn Watts married Sarah Chaney in services at the home of his mother, Polly (Noble) Watts, in the community of Watts, Kentucky. Bessie (Campbell) Watts, Will Penn's first wife, died on December 3, 1934, from complications one day after the birth and death of their son, William Penn Watts Jr. Bessie Watts was buried in the Sunny Orchard Cemetery behind the family home on Leatherwood Creek.

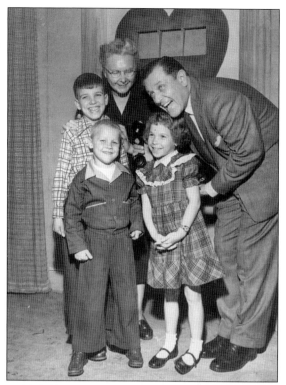

Esther Pushee and students (left to right) Pearl Hudson, Johnnie Desmond, and Delores Short appeared on the controversial CBS television and radio network program *Strike It Rich* in New York on November 5, 1952. During the program, master of ceremonies Warren Hull asked the children a series of questions that helped net more than $1,160 in cash, a gross of towels, 100 baby chicks, 78 pairs of shoes, lots of clothing, and more than 50 pounds of candy for the children of the Dessie Scott home.

William Everett and Pearl (Day) Back celebrated a milestone by cutting the cake with family and friends, including Esther Pushee (left). W. E. Back and his wife were very faithful supporters of the Little's Creek Mission and later the Dessie Scott Home for Children after it moved from Breathitt to Wolfe County.

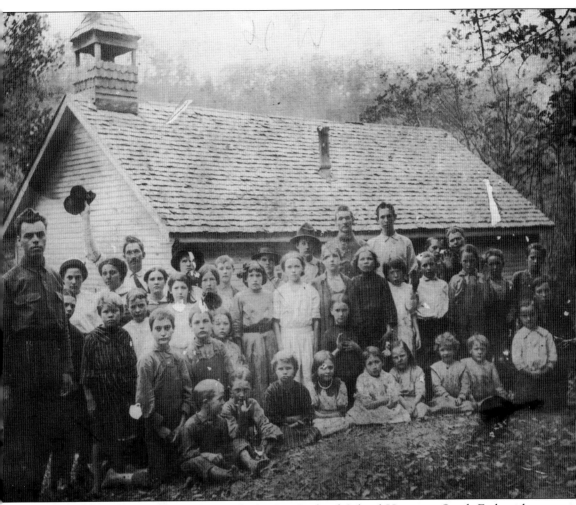

Teacher Fallen Campbell stands outside the Big Orchard School House on South Fork with members of his class in 1913. Campbell started his teaching career in Breathitt County before accepting a position with the Eastern State Teacher's College in Richmond, Kentucky. He later went on to serve the students of the commonwealth as executive director of textbook distribution for the Kentucky Department of Education.

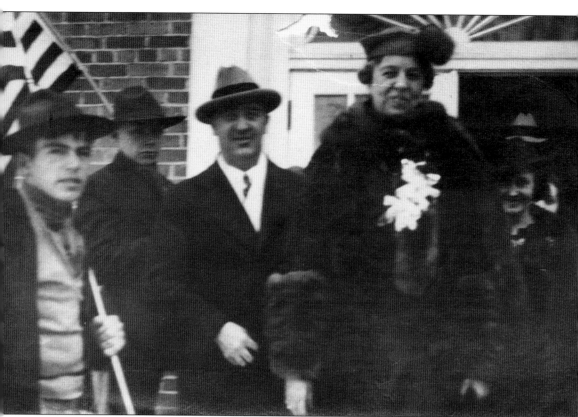

On January 27, 1938, First Lady Eleanor Roosevelt rode a special chartered L&N train to Jackson and officially dedicated the new Breathitt High School building. She was accompanied on her trip to Jackson by Kentucky governor A. B. "Happy" Chandler and Mrs. Henry W. Morganthau (Elinor), wife of the U.S. secretary of the treasury. Mrs. Roosevelt encouraged the children of Breathitt County to "lift up their heads and dream" during her dedication remarks.

John Wesley Stamper and his second wife, Nancy (Bowling) Stamper, had only two children, Chaney and Elijah. John Wesley was a veteran of the Civil War, in which he fought as a private in Company K of the 14th Kentucky Cavalry. His first wife, Agnes (Turner) Stamper, died in the 1880s, and he married Nancy Bowling on September 9, 1890. Nancy had previously been married to John Turner, who died on Turkey Creek on May 6, 1889. Together John Wesley and Nancy raised a family of 13 children from their marriages and were widely known in the Morris Fork and Long's Creek communities in Breathitt County for their support of the schools in that area.

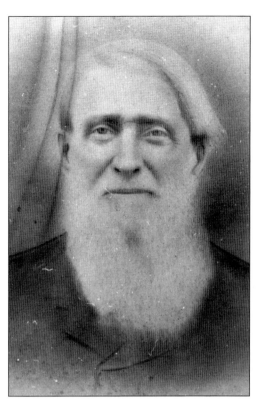

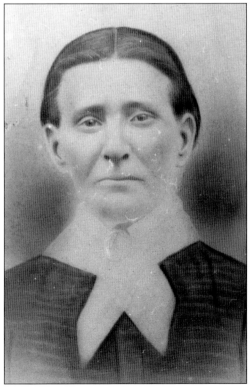

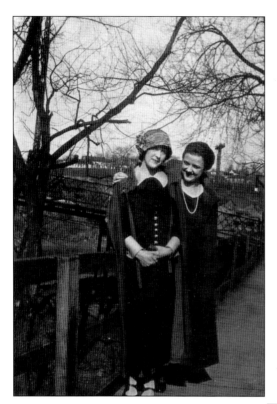

Best friends Adeline (Childers) Smith, left, and Bess (Hatton) Spoonamore posed on the wooden walkway at the end of the South Jackson bridge in 1926 for a picture. Bess Spoonamore was an employee of the First National Bank on Main Street at the time of this photograph. Both ladies were known for their high fashion and style.

Longtime Jackson businessman Robert Clay "Bob" Wallace's barbershop, located on College Avenue, was the center of activity and the pickup and drop-off point for the Greyhound bus service from Lexington to Jackson. Bob raised his family on Highland Avenue and was a supporter of the Rosenwald School, Jackson's only African American school, on Hurst Lane in the Ewe Hill section of Jackson.

Through the years, Breathitt County has had its share of strong, hard-working women. One of those was Bertha (Hudson) Noble of Hardshell, Kentucky. Seen here with, from left to right, her children Reed, Talbert, Emory, and Bill, Bertha was the daughter of Talbert and America (Campbell) Hudson and was married to William "Bill" Noble in 1917. She died in 1947 and is buried at the Tater Knob Cemetery at Hardshell.

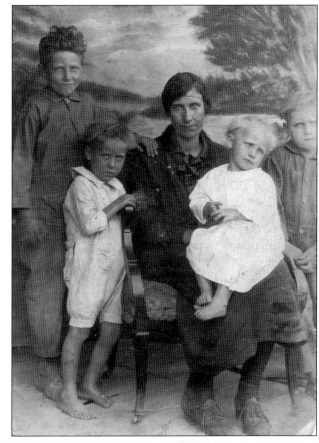

One of the most popular recreation spots for the people of Jackson, the rock formations of the Indian Post Office was accessed by crossing the swinging bridge at the end of Court Street. The Indian Post Office and the Devil's Backbone were connected by the narrow Panhandle until Highway 15 was constructed in the 1960s and most of the rocks were blasted away.

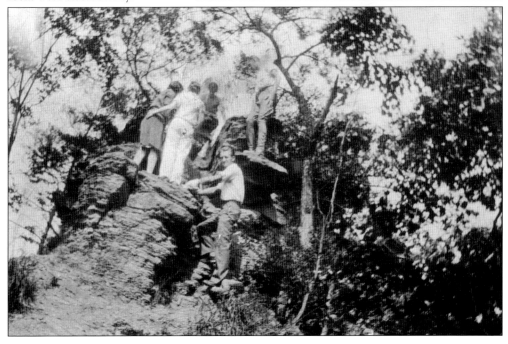

Amos Fugate gained a reputation for his quick gun and even quicker temper. Known as "Bad Amos" Fugate, he was reputed to have killed at least four men and two women. In 1922, he was betrayed by several friends and hunted down by a posse seeking his arrest for the murder of two women over an argument about a goose. He was shot numerous times and died near a small cabin on Lick Branch of Ball Creek.

Lees Academy (later Lees College) was a social hot spot at the start of the 20th century, as both men and women were educated at this mountain school. These ladies found a shady spot on the campus of Lees Academy to relax about 1900. They are, from left to right, Margaret Snowden, Amelia Ann Snowden, Jessie ?, ? Eversole, Emma Clark, and Lizzie Cope.

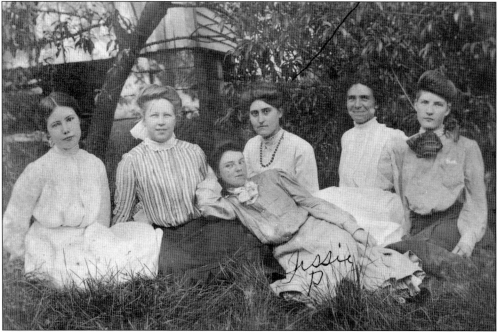

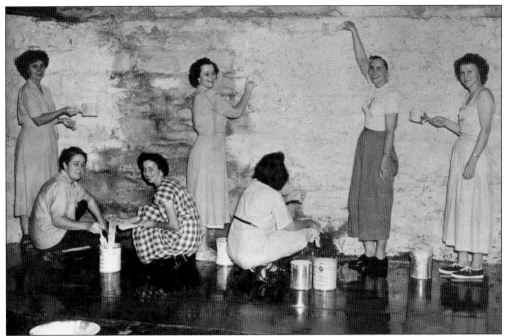

The Jackson Woman's Club adopted the basement gym of the Jackson Christian Church on College Avenue as one of their community development projects. The club collected donations and then cleaned and painted the facility before opening it for community activities. The club sponsored volleyball, exercise, badminton, and other activities, including dances and other recreational opportunities. The Jackson Woman's Club and the Jackson Christian Church continued this arrangement for more than 10 years until most of the activities were moved to the campus of Lees College.

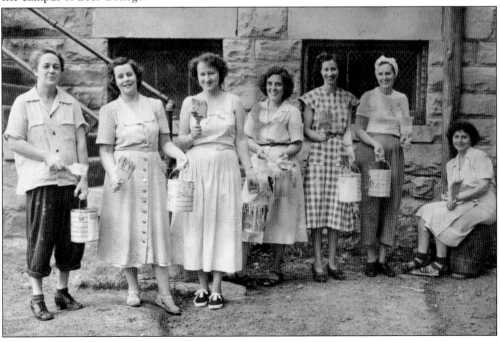

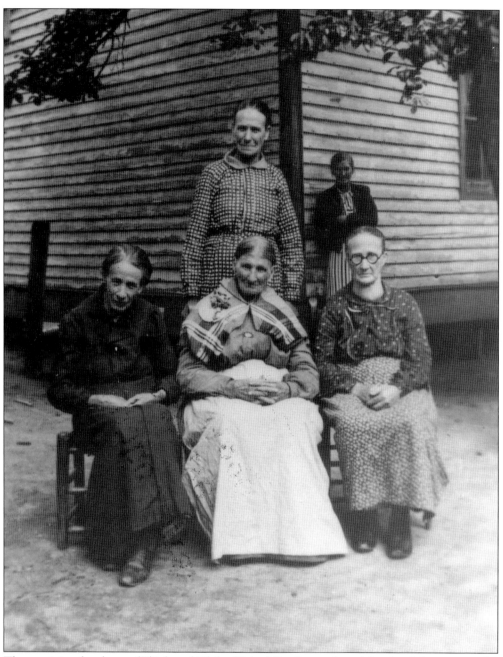

The surviving daughters of Elijah and Zilpha (Baker) Bowling gathered for a birthday party in the 1940s. This photograph shows, left to right, Sally Ann (Bowling) Spicer, Nancy Ann (Bowling) Stamper, and Polly Ann (Bowling) Stamper. Their sister, Lavina Bowling, is standing behind them, and Nancy's daughter-in-law, Litha (Sebastian) Stamper, is leaning against the house.

Lela G. McConnell was born in Honey Brook, Pennsylvania, in 1884. While attending Asbury College, McConnell joined the Mountain Missionary Society and moved to Breathitt County to start a school following her graduation in 1940. She founded numerous schools, churches, a radio station, and a community in Breathitt County during her years of service to the people of the mountains. She was awarded an honorary doctorate from Asbury College and lived her life in the service of the mountain people until her death in 1970.

Made of steel cable and wooden decking, hundreds of swinging bridges once provided access to Breathitt County homes and communities isolated by the branches of the Kentucky River. The wooden structures were gradually replaced by modern steel bridges and roadways for vehicles. There are still more than 100 swinging bridges, so called for the swaying motion created by a person walking across the bridge, in use today.

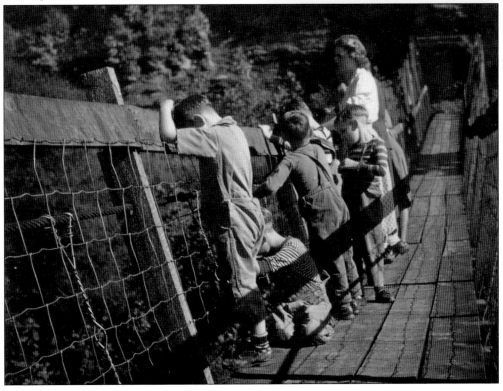

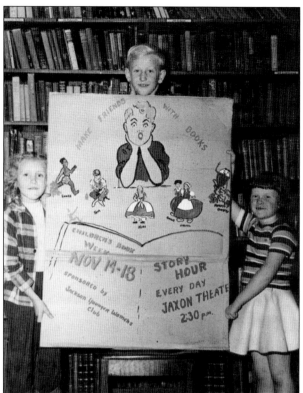

The Breathitt County Public Library and the Jackson Younger Woman's Club joined forces to celebrate National Children's Book Week by conducting story time events throughout the day at the Jaxon Theater on Main Street. Children from across the city and county came to listen to storytelling and book readings and enjoy snacks and the cartoon reels at the theater during the week of November 14–18, 1949.

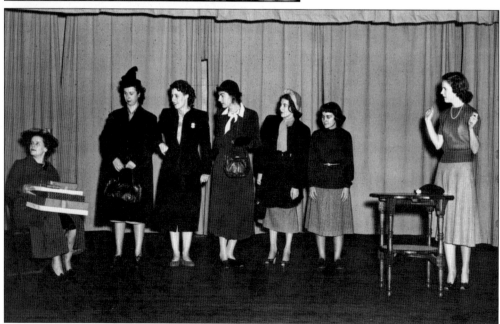

In November 1949, the play *Wisdom for Wives* was staged at the Breathitt High School auditorium, with all the proceeds going to support community events. The cast included, from left to right, Mrs. Estill Slone, Anna Mae Lemons, Mrs. T. K. Strong, Sarah Pinckney, Mrs. Steve Bach, Virginia Miller, and Mrs. Mize Hensley.

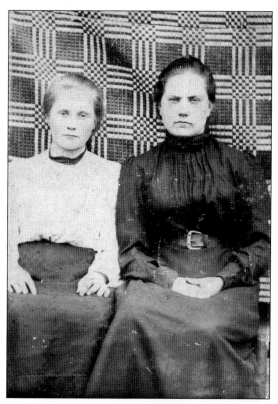

Callie (Wilson) Carpenter, left, and her sister, Elizabeth (Wilson) Back, used a beautiful hand-woven coverlet as a backdrop in this 1902 photograph taken at their home near Quicksand. Callie and Elizabeth were the daughters of John C. and Elizabeth S. (Butler) Wilson and the granddaughters of Breathitt County attorney David K. Butler.

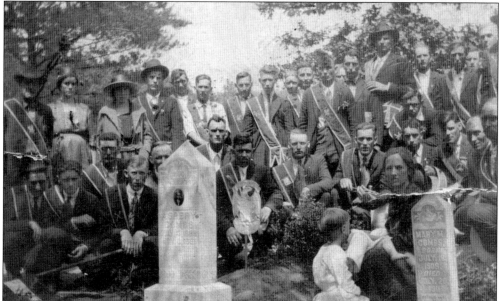

One of the bloodiest political battles in the long history of Breathitt County was the November 8, 1921, Clayhole election fight that left five people dead and numerous others with scars for life. In 1922, members of the Order of Red Men and the Junior Order of American Mechanics joined the widow and children of one of the Clayhole victims, Asberry Combs, at his grave for a memorial service.

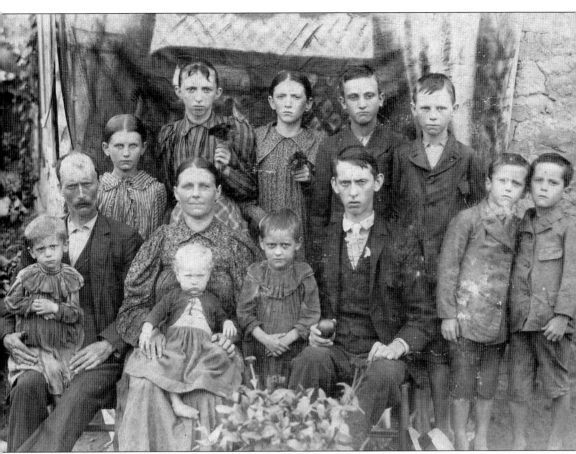

The Nathan Pelfrey family posed for this portrait about 1895 at their White Oak home in Breathitt County. From left to right are (first row) Nathan Pelfrey holding Sheldon Pelfrey, Sarah Turner (Sewell) Pelfrey holding Peggy Pelfrey, Ella (Pelfrey) Turner, Will Henry Pelfrey, and twins Walter Raleigh Pelfrey and Carl Roland Pelfrey; (second row) Eva (Sewell) Cope, Georgann (Pelfrey) Pence, Nancy (Pelfrey) Hounshell, Logan Pence (Nathan's nephew), and John G. Sewell. (Courtesy of the BCPL.)

Edward Fugate was a well-known and respected man when election time came in the Lost Creek and Ned precincts. Born in 1871 and the son of Civil War veteran Lewis N. Fugate, Ed loved politics and raised his family to vote for the Democrat party. In later life, he suffered from severe arthritis and was often confined to his favorite rocking chair in the years prior to his death in 1942.

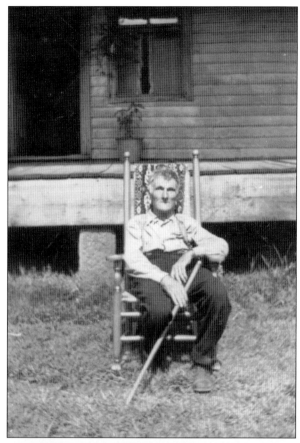

Longtime educator McCreary Roberts conducts "Let's Find Out Class" in 1960 for the sixth-grade class at Quicksand Grade School. Roberts became synonymous with excellence in education for his devotion to his students and his love of teaching. Known as a tough but fair teacher, Roberts was later one of the best-loved local authors who wrote about life in the mountains of Breathitt County and eastern Kentucky.

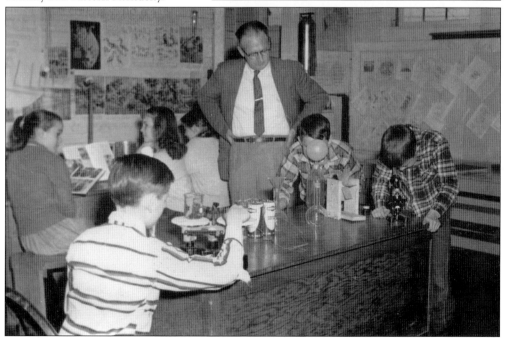

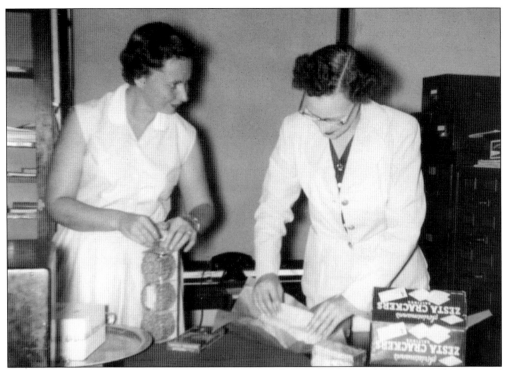

The Breathitt County Health Department and the Jackson Woman's Club planned and conducted more than 20 special health clinics for children in the Jackson and Breathitt County area. In 1953, Dr. Carl Friesen of Lexington, Kentucky, came to Jackson and, during the day, saw more than 100 people under the age of 21 with crippling diseases, such as bone and joint disorders, burn scars, cleft palates, and various other disorders. To the delight of most of the children in attendance, the day included a meal, complete with sandwiches, peanut butter and crackers, and other sweet treats prepared by the woman's club, all topped off with several hundred pints of milk donated by the Pet Milk Company. (Both, courtesy of the BCPL.)

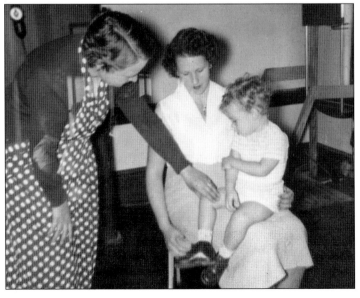

The work for a housewife in the mountains of Breathitt County was never done. Long hours in the field coupled with housework often left little time for meal preparation. Hours over a hot, wood-fired stove were made easier when the highway system allowed store-bought food to be delivered to rural grocery stores. In this image from the 1950s, a housewife at Whick prepares a quick and easy meal of Uncle Ben's Cream of Wheat.

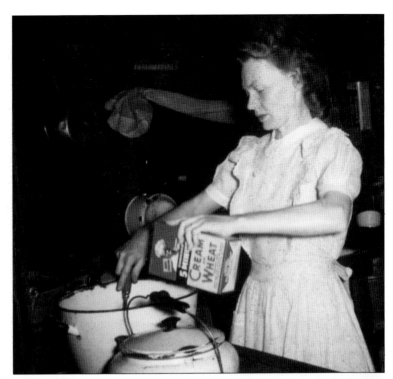

Miss Patsy, as she was known, operated a mission at Canoe for more than 60 years before her death in 1981 at the age of 105. Patsy (Bratton) Turner stopped at the gate of her Joe Little Fork home at Canoe to pose for a photograph with her husband, Seldon Turner, and their adopted children Stephen (left) and Carl Stamper (right). Miss Patsy was a Presbyterian preacher who ministered to the people of the Middle Fork area for more than 60 years.

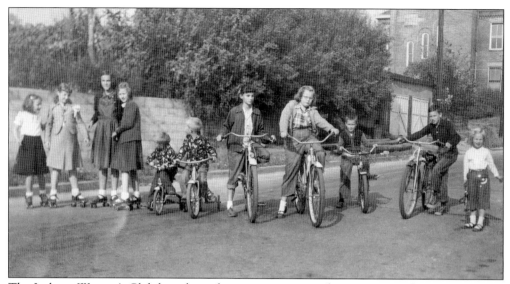

The Jackson Woman's Club has always been active in providing recreational opportunities in Breathitt County. In 1954, College Avenue was closed two days a week to automobile traffic from Red Reynolds's Ford Garage to the campus of Lees Junior College. On those days each week, the street was opened for skaters and bicyclists only.

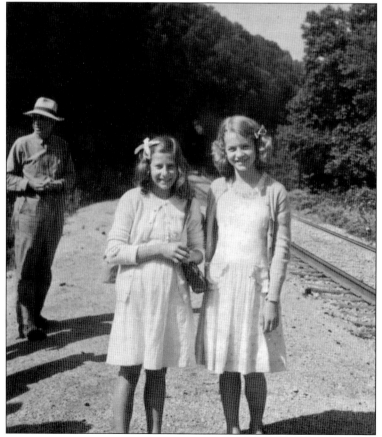

Two girls from the John Little's Creek community stand by the tracks and wait for the train. In many instances, the L&N passenger train was the primary and most reliable means of communication and transportation into and out of the remote corners of Breathitt County prior to a paved highway system. The L&N operated numerous passenger trains that ran from Jackson to McRoberts and back every day.

Most of the photographs of the heyday of Quicksand and Breathitt County were taken by photographer Claude Duval Back. Duval married Nancy Dixon in 1896 and raised their family on the Henry D. "Snoot" Back farm near the mouth of South Fork. Duval was killed on April 18, 1930, after he wrecked his automobile, making his death one of the first in Breathitt County as the result of a vehicle crash.

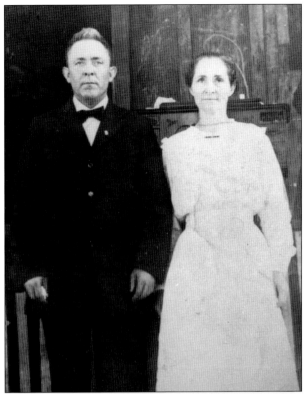

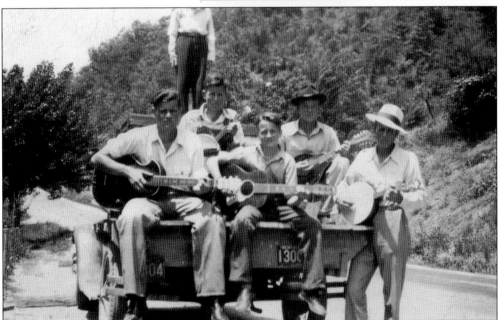

A truckload of musicians gathered and played on the side of Quicksand Road about 1940. This band includes, from left to right, James Carl Combs, Charles "Jake" Combs, Earl Clemons, Billie Clemons, and Floyd Clemons. Price Floyd Combs can be seen standing in the back of the truck listening to the music the others played.

When the voters of Breathitt County approved the creation of a taxing district to fund the creation of the Breathitt County Public Library in 1968, Carrie (Grigsby) Hunt was hired as the first director. Born in 1915, Carrie was the daughter of Breathitt County sheriff Johnnie Grigsby and his wife, Lucinda (Ritchie) Grigsby. In 1937, she married Ray Hunt, and they raised their son, John, in Jackson before her death in 1979.

Wash day was a regular occurrence for the average housewife in Breathitt County. Not until power lines were installed throughout the area was the age-old tradition of hand or washboard abandoned due to the introduction of electric ringer washers. Not until many years later were local housewives able to forego hanging the wash in favor of an electric dryer.

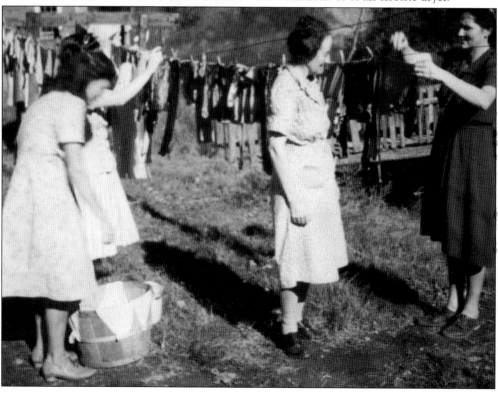

For many years, Dr. Farren Cohen "F. C." Lewis operated a doctor's office in the basement of the Jefferson Hotel. Dr. Lewis and his staff of many years, nurses Florence (Smith) Dillard (left) and Mary Jane (Hudson) Dunn, are seen here talking with Margaret Helen Lewis (sitting), Dr. Lewis's wife. During his years of medical practice in Jackson, Dr. Lewis treated thousands of local residents suffering from various ailments, gunshot wounds, and diseases, as well as delivering hundreds of babies.

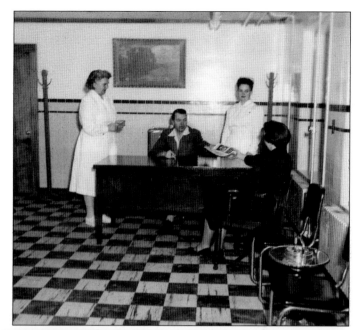

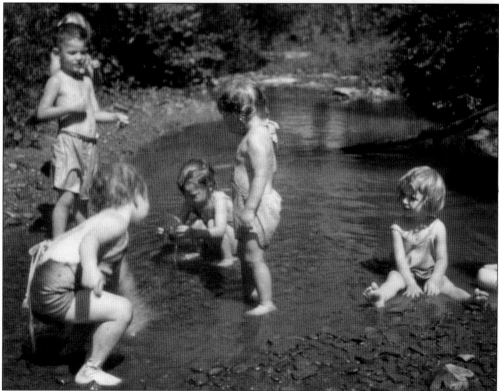

Children from the Little's Creek community played in the creek during the hot days in the summer of 1951. Breathitt County has more than 215 major creeks that empty into either the North Fork or the Middle Fork of the Kentucky River. Water has always been the most important resource to the people of Breathitt County, both economically and subsistence-wise.

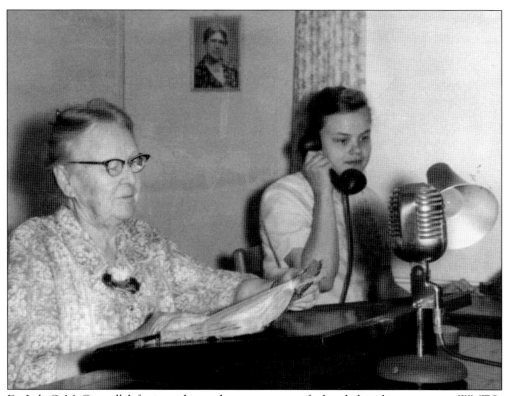

Dr. Lela G. McConnell, left, sits with a student programmer for her daily radio program on WMTC. Dr. McConnell was a midday fixture on the radio, as she would lean into the microphone to read from the Bible and preach to radio listeners from across the area.

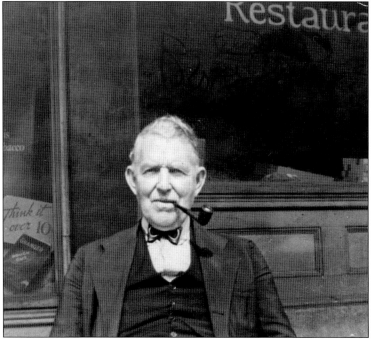

One of the most popular hamburger spots in Jackson was Manns' Restaurant, located near the L&N depot in South Jackson. Owned by Curtis J. "Curt" Manns, the restaurant was famous for his "grilled fried" hamburgers and cheese. In this image from 1926, Manns sits in the morning sun to enjoy his pipe outside his business while waiting for the first trainload of customers to arrive at the depot across the street.

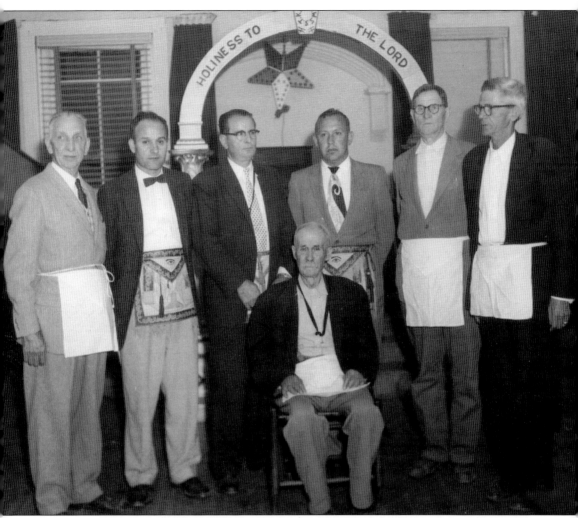

The officers of Breathitt Lodge No. 649 posed for this picture in the lodge hall on Court Street in 1957. The members present for the photograph were, from left to right, Ben C. Sewell, Senior Warden J. Gordon Combs, Master Frazier B. Adams, Junior Warden David B. Watts, and members Allison White and Ike Watts. Sitting is Tiler ? Miller. The Masonic lodge was created by the Grand Lodge of Kentucky in 1891, and over the years, the lodge met in the courthouse, the Hogg Building, and several other places before building a permanent structure on Court Street. In 2002, the lodge sold the Court Street building and built a new lodge hall on Broadway.

Square dancing and more formal dancing lessons were offered in the basement of the Jackson Christian Church on College Avenue as a means of allowing Jackson residents to get "a little more exercise," according to their promotional flyers. On busy nights, participants often stood in line for the chance to show off their moves during the very popular community programs.

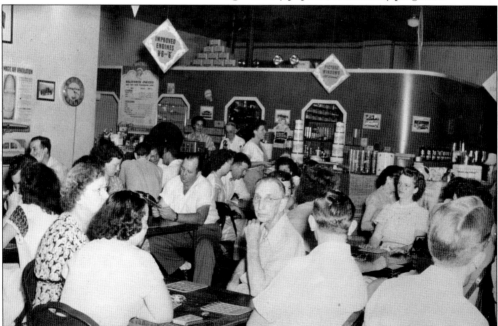

Bingo at William H. "Red" Reynolds's Ford car dealership on College Avenue was a popular event in Jackson each Friday night. The weekly event was the hit of the town for those who tried their luck at winning such fabulous prizes as an oil change, tire rotation, $10 prizes, or the grand prize of a 10-pound canned ham. These events were sponsored by the Jackson Woman's Club.

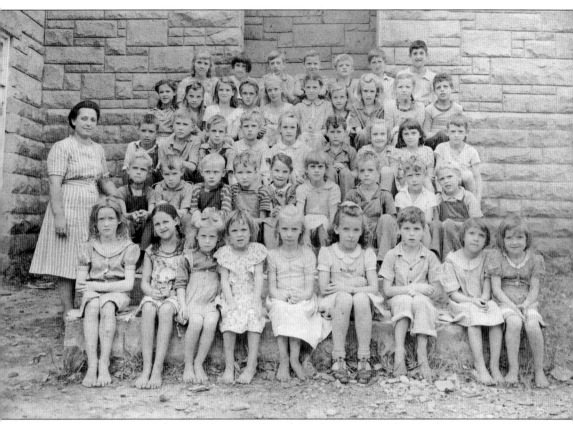

Rousseau is a community located along Quicksand Creek approximately 15 miles east of Jackson and was home to the Back, Calhoun, Minix, and other families. Rousseau School educates students from one-third of Breathitt County and from every branch of Quicksand Creek. In 1946, Eva Lovely's fourth-grade class posed for a picture on the steps outside the original school building, constructed by the WPA in the 1930s to replace the old wooden structure that had been used for years. Some of the identified students include Elizabeth Back, Betty Day, Shirley Combs, Pearl Fugate, Ina Bowling, Audrey Watkins, Bert Barnett, Raymond Armstrong, Rhonda White, Ruby Barnett, and Mazel Caudill. Rousseau School later closed the original WPA school and moved into the modern brick structure it calls home today. Since moving into the new Rousseau School, floodwaters have inundated the building twice, destroying most of the contents.

The Breathitt County Health Department visited every school in Breathitt County in an effort to update the immunizations of Breathitt County children and to provide vitamins. In 1954, Oda Spencer at Jackson City School distributed vitamins to members of her first-grade class in an effort to improve the health of the future leaders of Breathitt County. (Courtesy of the BCPL.)

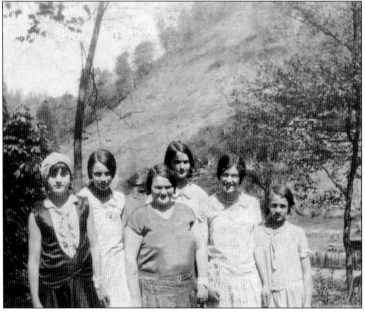

A group of girls stopped for a moment during an afternoon walk on Stray Branch in South Jackson in 1930. The group included, from left to right, best friends Artha Mae (Gross) Ewing, Dorothy Terry, Elsie (Gross) Chaney, Jessie (Keith) Turner, Eleanora Terry, and Rosa Potter. The girls attended Stray Branch School together, and the group was a common sight from the head of the hollow to the railroad tracks.

The children of "Granny" Mary Wilson stand for a photograph near their Shucky Bean Hollow home in Snake Valley near Jackson. The twins, Henrietta and Henrisie Wilson, stand proudly with their nephew, Brown Wilson. Henrietta married prominent Jackson businessman Robert Wallace and raised their family in Jackson. Their daughter, Brownie Wallace, was the first African American to graduate from a desegregated Breathitt County school system.

The Town Dandies, as they were known, gathered behind the Hargis feed barn on June 2, 1909, for this image. The Dandies included, from left to right, (first row) Kelly Back, Lloyd Back, Junior Back, Charlie Gabbard, and Kenny Risner; (second row) Ormond Elam, P. Watt Howard, and three unidentified men.

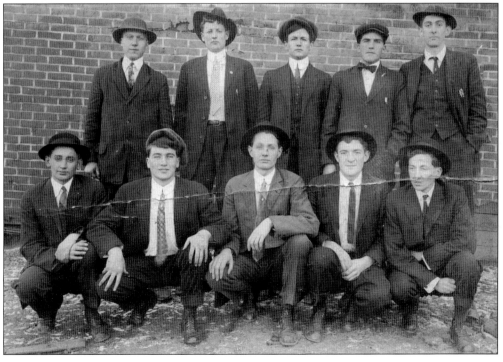

By all accounts, Asberry Spicer was a tough man. This photograph, taken in 1908, shows one of Jackson's most notorious bad men shortly before he escaped police custody, never to be seen again. Asberry was implicated in several of the murders that occurred during the Hargis-Marcum-Cockrell feuds. In court testimony, witnesses claimed that he was a hired gunman for Judge James H. Hargis and Ed Callahan and one of the assassins of Dr. Braxton D. Cox.

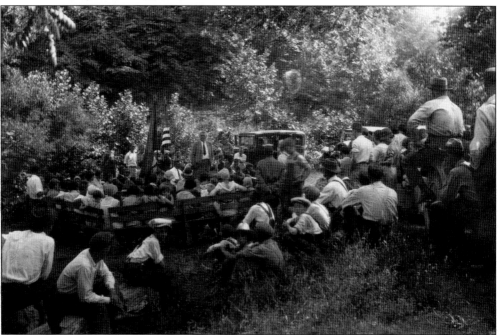

Politics has long been the lifeblood and a great source of entertainment for the people of Breathitt County. The men and women from across the predominantly Democratic-leaning county would gather every four years to listen to speeches and enjoy free food and entertainment for the primary election in May, because there was traditionally no opposition from the Republican party for the general election in the fall.

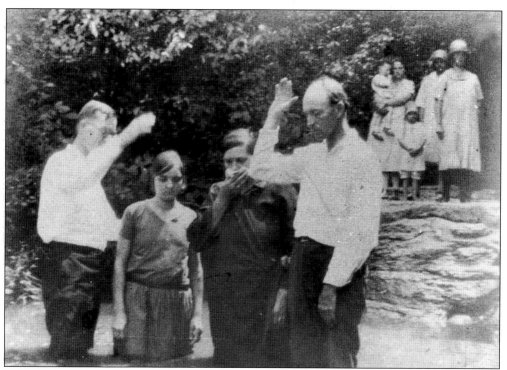

Religion has always played an important part of the daily lives of the people of Breathitt County. In this undated photograph, two ministers prepare to baptise a mother and daughter in a local creek. Baptisms were usually large social events, and as many as 15 people would often be plunged beneath the waters in daylong "meeting and dinner on the grounds" events.

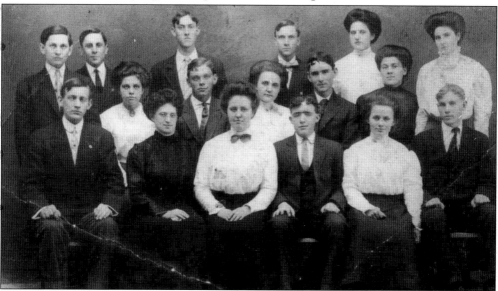

Breathitt County residents attended Berea College in full force in 1908 in pursuit of their teaching degrees when this photograph was taken. Included in the photograph are Asher Strong, Thomas Terry, Robert Brashear, Ruth Hurst, Zachariah Hurst, two Holbrook brothers, Sarah Creech, Mollie Gabbard, Brice Cundiff, Etta Terry, Hattie Davis, Mattie Davis, and Margaret (Hagins) O'Mara.

Carrie Day was the daughter of William and Rowena (Morrison) Day and grew to adulthood on the banks of Frozen Creek. In 1908, she married Hiram June Jett, a prominent Jackson businessman. For years, Carrie (Day) Jett suffered with a cancer that developed on her arm. She died despite the best efforts of doctors on January 5, 1930, and was buried in the Day Cemetery on Frozen Creek.

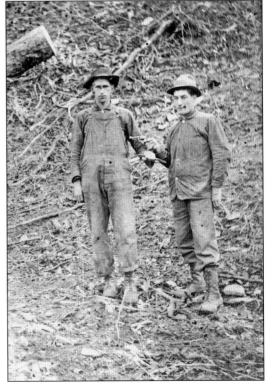

Lumbermen Everett Morgan (left) and Alfred Tharp stand ready for action in this scene taken near their home on South Fork. Breathitt County men like Morgan and Tharp worked to cut the large chestnut, poplar, walnut, and oak trees that once covered the mountains of eastern Kentucky to meet the needs of the timber industry as far away as Massachusetts and beyond. The grueling and often dangerous work of a lumberman claimed the lives of hundreds of men throughout Breathitt County.

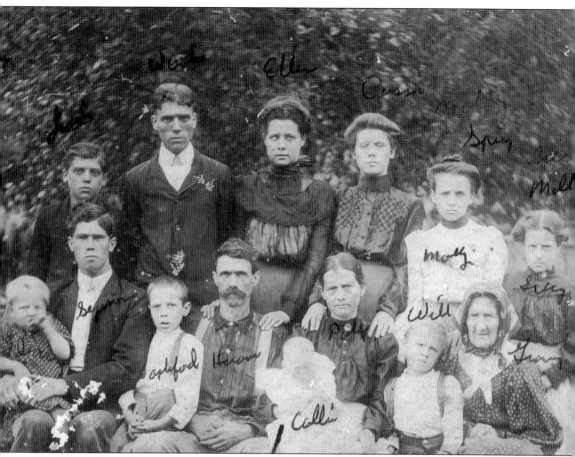

The Hiram Watts family was one of the largest families in the Leatherwood Creek community. This photograph from 1905 includes, from left to right, (first row) Horatio Seymore Watts holding Ashford Watts; Will Penn Watts; Hiram Watts; Polly Watts holding Callie (Watts) Porter; Isaac Watts; and Polly's mother, Phoebe (Campbell) Noble; (second row) Lewis Henry Watts; George Washington Watts; Ellen (Watts) Noble; Cassie (Watts) Noble; Mollie (Watts) Noble; and Spicy (Watts) Noble. The Watts family was very influential in Breathitt County Democratic politics, and several of the children were prominent teachers, including Ellen. "Granny Phoebe" was the wife of George Washington Noble, who was killed by Union raiders on November 3, 1862. Throughout her life, Phoebe lived with her children, including Polly Watts. Hiram Watts died in 1925, and Polly (Noble) Watts died in 1947. They were buried in the Sunny Orchard Cemetery near their home in Watts.

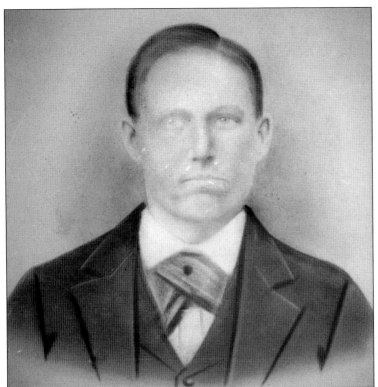

James Monroe "Roe" Taulbee, the son of James Perry and Elizabeth (Dunn) Taulbee of Frozen Creek, raised a large family of 12 children on Frozen Creek. He married Nancy Jane Brewer, the daughter of Jefferson and Gillian (Childers) Brewer. Roe Taulbee died on May 17, 1938, and is buried in the James Perry Taulbee Cemetery on Bloody Creek in Wolfe County.

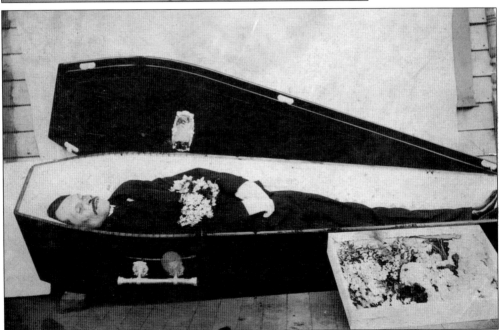

Deputy Sheriff Grant Holiday was called to a disturbance and was shot and killed instantly by "Bad" Jake Noble on December 10, 1905. His funeral was conducted at the Baptist church by Rev. J. H. Hudson of Noble, after which his remains were buried in the Combs Graveyard on Hurst Lane in Jackson, with full services by the Knights of Pythias and the Order of Red Men.

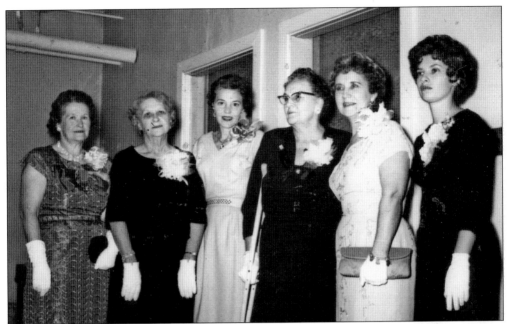

Members of the Jackson Woman's Club formed a receiving line at a silver tea reception given on November 16, 1961, in honor of National Mother of the Year candidate Josephine W. Back. The receiving line included (from left to right) Victoria Whisman, Jalia Allen, Audrey Hays, Elizabeth Holliday, Josephine W. Bach, and Janet Noble. The reception was held in the recreation room of the Van Meter Gym on the campus of Lees College.

Adolph and Katherine (Redwine) Allen made a trip to the Jackson L&N depot to visit the *General* as it made a nationwide tour to promote the 1956 Disney film *The Great Locomotive Chase*. The special event drew a large crowd to the depot to see the restored engine that was used in the filming. A great view of the Jackson depot can be seen in the background.

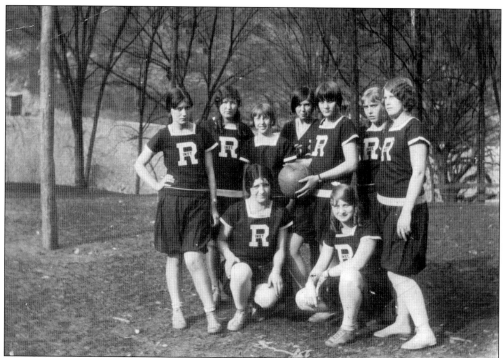

For many years, women's basketball was outlawed in the state of Kentucky, but prior to that period, women's teams flourished across the state. This 1920s-era basketball team from the Riverside Christian Institute displays the modest uniforms of the time that often caused some stir due to the exposure of their legs.

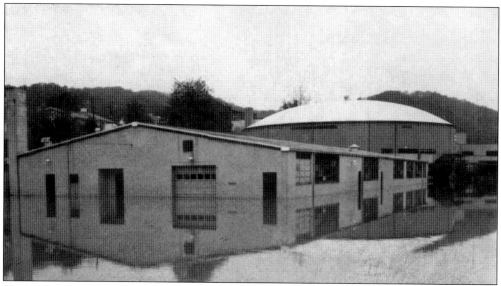

One of the most devastating floods in the long history of flooding in Breathitt County occurred in 1984 as floodwaters reached 41.97 feet on May 8. During this flood, water covered part of Broadway and filled the Breathitt County Vocational School and the campus of Breathitt High School. At its peak, the north fork of the Kentucky River was flowing at a rate of 53,500 cubic feet of water. (Courtesy of the BCPL.)

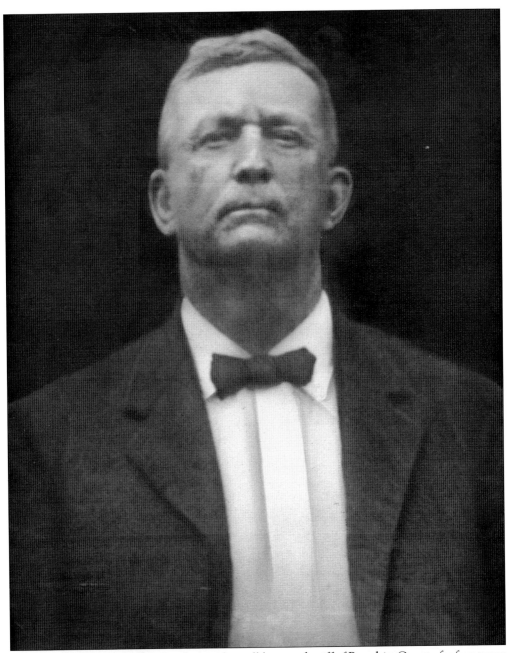

William Henry Breckinridge Combs was the well-known sheriff of Breathitt County for four terms in the late 1800s. Born in 1856, he is best known as the executioner of "Bad" Thomas Smith, the notorious mountain feudist. Breck Combs was one of the most prominent Democrats and one of the wealthiest landholders in the county. He was the son of William Mason and Sarah Jane Combs of Snake Valley and lived most of his life in the city of Jackson. On May 10, 1874, he married Susan Strong, the daughter of County Judge Edward Callahan Strong and his wife, Nancy (Haddix) Strong. His father, William M. Combs, served six terms as Breathitt County jailer. Breck Combs died on May 10, 1925, at his home 1.5 miles from Jackson on Old Quicksand Road. He was laid to rest in the family cemetery on Hurst Lane.

Archelus Fulkerson Lyons was a well-known businessman in Jackson and was, for years, a very influential member of the Jackson Masonic Lodge. He married Jane Hardin, the daughter of Anders Henry and Levica (Jones) Hardin, and lived in Jackson. He died on August 18, 1939, and is buried in the Sewell Cemetery on Marcum Heights.

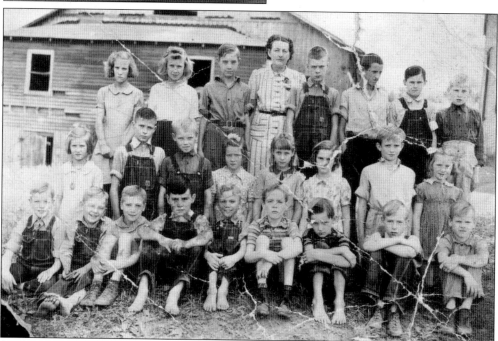

Students in Mrs. Turner's class at the Quicksand School standing beside the building for this photograph included Lawrence Miller, Virgil Dunn, Bill Frazier, Betty Lou Truesdell, Billy Hays, Leonard Hollan, Jean Bernett, Mary Lou Cox, Don Mooney, Ray Miller, and Jackson Brown. Years later, the Quicksand Grade School was moved to Little Red as part of the county consolidation of schools.

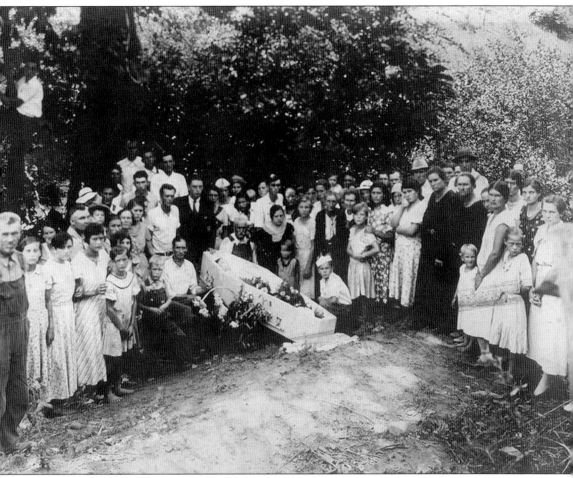

The tragic story of Adna (Jones) Gabbard has been captured forever in this photograph taken on July 14, 1933, at the Flatwood Cemetery. Born on August 7, 1907, Adna was one of several children born to Floyd and Sarah Jane (Allen) Jones from the community of Buckhorn Creek. On July 12, 1933, Adna Jones was married to Thomas J. Gabbard against her wishes. She had been employed as a teacher on Quicksand Creek for more than a year in the Breathitt County school system. According to the family, she did not want to marry but felt pressured. During her honeymoon night, Adna took a revolver and committed suicide by shooting herself through the left breast while sitting at the kitchen table. She was buried near her childhood home on Buckhorn Creek. Her grandfather, Alfred A. "Smokey" Allen, made all of the arrangements and can be seen sitting at the head of the casket with the white mustache. Her husband, Thomas Gabbard, is standing at the head of the casket in a black suit. (Courtesy of the BCPL.)

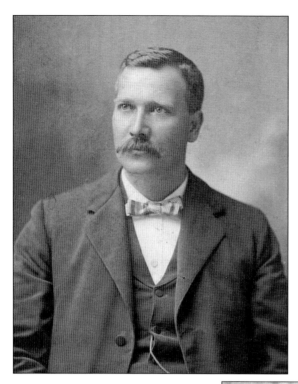

John Smith Redwine, M.D., was one of the best-known doctors in the commonwealth of Kentucky and a proud resident of Jackson. He served for years as the superintendent of the Eastern State Asylum for the Insane (now Eastern State Hospital) on Fourth Street in Lexington. He and his wife, Deborah Adeline (Combs) Redwine, were the parents of six children.

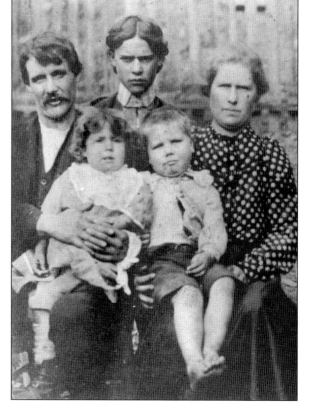

All dressed up for their photograph, the family of John Morgan Allen typifies the mountain family at the start of the 20th century in Breathitt County and eastern Kentucky. Pictures from this era of Breathitt County's past are very difficult to obtain due to the expense. Families often took only one photograph, and over time they have been lost to fires and flooding.

Born on September 7, 1812, Wiley "Horton" Amis was one of the most notorious feudists in Breathitt County during much of the "Bloody Breathitt" days. The son of Wiley Horton and Catherine (Bowling) Amis, Wiley was raised by his stepfather, Robert Baker, but did not take his name. When the feuds grew too violent, he moved his family to Searcy County, Arkansas, where he died on September 27, 1882.

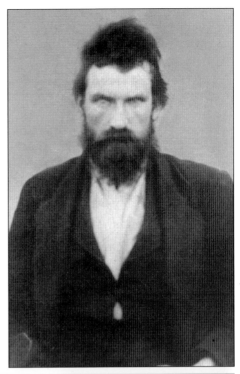

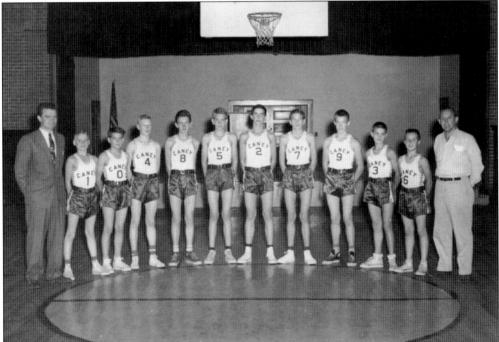

Principle Von Watts, left, stands with the proud members of the Caney Consolidated basketball team, including, from left to right, Stephen Combs, Kelly Landrum, Knox Napier, Troy Campbell, Chester Roberts, Hoy Marshall, Luther Clemons, Shade Smith, unidentified, Ollie James Miller, and David Watts, coach.

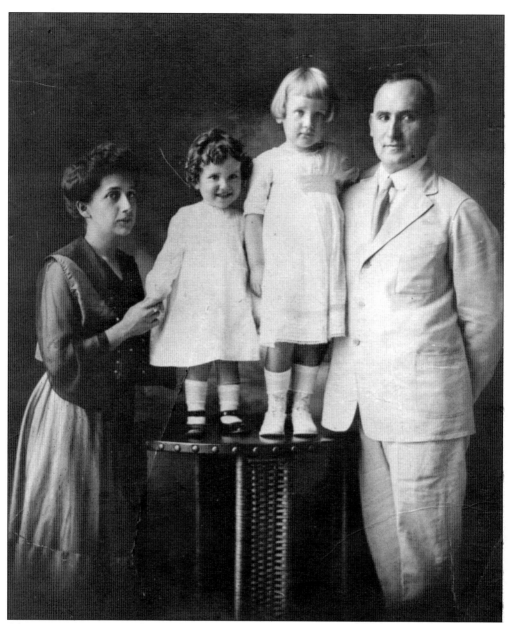

Always a prominent member of the Jackson Medical Association, Dr. Wilgus Back stands with his family for this portrait around 1916. Dr. Bach earned his medical degree from the University of Louisville and completed specialized surgery training at Tulane University in 1920. He was admitted to the American College of Surgeons on October 12, 1928, and operated the Bach Trachoma Clinic in Jackson from 1914 until his sudden death in 1936. He was considered an expert on gunshot wounds and pioneered a new method of skin grafting. Dr. Bach had a tremendous love of history and antiques. During his career, he collected vital genealogy statistics and information on thousands of people and families throughout southeastern Kentucky. Dr. Bach's research has been the foundation of more than 40 books and research projects since his death in 1936. He stands with his wife, Amanda (Duncan) Bach, and their children Stella Duncan Back, left, and Mary Edith Bach. A son, Wilgus Bach Jr., was born in 1913 but lived only 12 days.

Mitchell Schooler Crain was the son of William J. and Emily (Ingram) Crain. He and his brother, Jackson Porter Crain, opened the Crain Mercantile on Broadway at the start of the 20th century. The Crains were, for many years, the leaders of the Republican party in Breathitt County. Mitch Crain was married to Emily (Combs) Crain, who died unexpectedly in 1913. He later married Rachel Everage, and together they raised three children. Mitch Crain died in Lexington, Kentucky, on October 14, 1952.

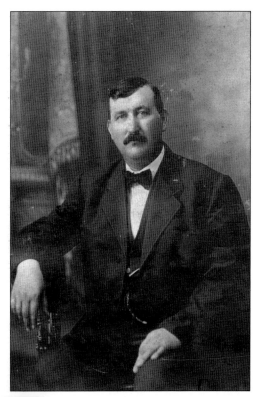

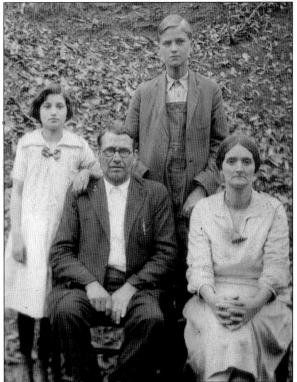

John E. Watts and his wife, Sarah "Sallie" (Noble) Watts, were married at Dibe Noble's home on February 27, 1908. The couple is seen here with their children, Luther and Pearlie Watts, around 1929. John and Sallie later left Breathitt County and moved to Indiana, where Sallie died in 1961 and John in 1967.

Sigel Arrowood, left, and his cousin, Samuel Turner, posed for this photograph at the A. S. Sizemore studios in South Jackson. Sigel and Sam were close friends throughout their lives. Sigel was the son of George Washington Arrowood and his wife, Louisa Turner. Samuel was the son of Edward and his wife, Eliza (Strong) Turner, of Whick.

In 1917, the Lost Creek Brethren Church Ladies Sunday School Group and Sewing Club posed for this photograph outside their new church building on the campus of Riverside Christian Institute. Seen here are, from right to left, Parrott Bowling, Maggie Landrum, Nancy Landrum, Serena Bell Landrum, Margaret Bowling, Mary Jane Hays, Betty Deaton, Ada Drushal, Dora Campbell, and unidentified.

Three

FOR GOD, GOLD, AND COUNTRY

RELIGION, INDUSTRY, AND SERVICE

Throughout the long history of the mountains of Breathitt County, three great forces have driven the people to strive for a better life, a better community, and a better world. In each instance that a need was known or duty called, mountain people have responded. Chapter three is dedicated to those who served their country, their neighbors, and their God through the military, industry, and the church.

Archibald Calloway Cope served as the captain of Company D, 5th Kentucky Volunteer Infantry during the Civil War. A native of Breathitt County, he raised his company of Confederate soldiers on Quicksand and Frozen Creek and fought throughout the war, surrendering in Georgia in 1865 more than a month after the war officially ended. He is buried in Cope Cemetery on Strong Fork of Frozen Creek with his wives, all of whom preceded him in death, and many of his children.

The Jackson Methodist Church (left) once stood on Court Street opposite the Breathitt County Jail and beside the Breathitt Masonic Lodge Hall. Lightning struck and ignited the church bell tower, setting the entire building on fire. Due to the lack of a city fire department, the structure was a total loss. The congregation moved across the street and constructed the Methodist church that is still in use today.

Cpl. Allie Young Watkins served proudly in the U.S. Marine Corps during World War II before his return to Breathitt County to practice law. Allie served for several years as the Breathitt County attorney. He was married to Ethel Barnett and later Helen G. Hollon. Allie was, for years, one of the brightest members of the Jackson Bar Association before his death in 1979.

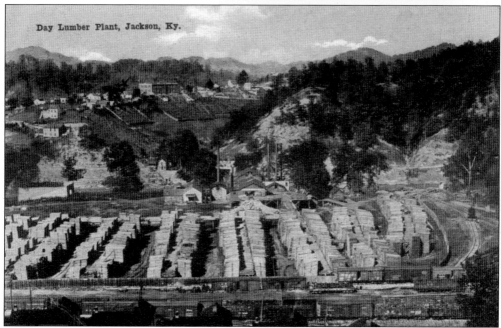

Located in the broad river bottomland of South Jackson, the Day Lumber Company (later the Swann-Day Lumber Company) was one of the largest operations in the world, shipping millions of board feet of lumber around the country every year. The large stacks of curing lumber can be seen in the postcard view from the early 1900s.

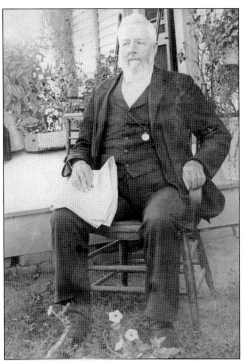

Union Civil War veteran Henry Clay Lilly served two terms as the circuit court judge of Breathitt County and surrounding counties. During his terms, he wrote numerous letters to the governors of Kentucky requesting the deployment of Kentucky State Guard troops to Breathitt County in order to maintain a fair and open court system. Two governors responded to Colonel Lilly's requests by installing machine guns and troops on the public square around the courthouse.

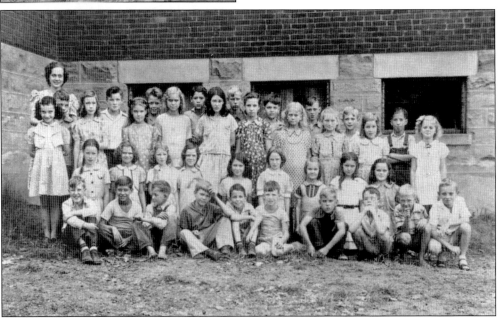

Members of this Jackson City School class posing outside the elementary school for a photograph include, from left to right, (first row) LaRue Thorpe, Jerry Little, Jerry Noble, unidentified, Jimmy Brown, Jackie Slone, unidentified, Edsel McCoun, Bill Wamble, and Dick Eversole; (second row) two unidentified, Jean Robinson, Mary Barnett, Vanda Murphy, Joy Allen, two unidentified, Mary Terry, and unidentified; (third row) unidentified, Ollie Slusher, Ola Mae McCleese, four unidentified, Juanita Hollon, C. B. Dunn, and Patsy Lemons; (fourth row) seven unidentified and Paul Watkins. (Courtesy of the BCPL.)

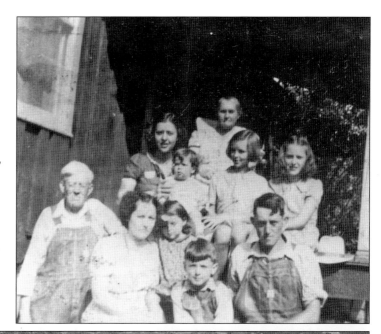

Some of the children and grandchildren of the Sampson "Samp" Moore family posed for this photograph on the steps of their home. Included are, from left to right, (first row) Samp Moore, Bess Moore, Betty Jo Deaton, Arnette Moore, and Sanford "Dime" Moore; (second row) Julia Moore holding James Roger Deaton, Eliza Moore, and Lois Moore. Samp Moore's wife, Jane "Teent" (Spicer), Moore is sitting in the chair in the rear of the group on the porch.

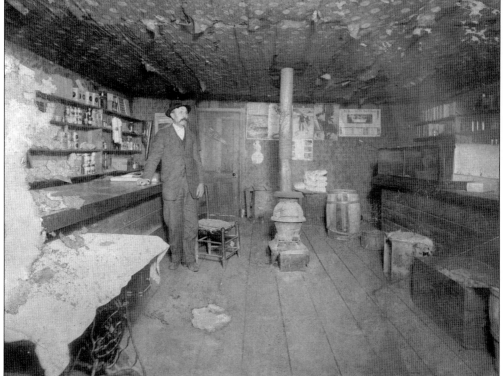

The view inside the Newton J. Moore store on Broadway shows one of the most popular hangouts in the city of Jackson. Newton Moore, left, would have a store filled with men sitting around the pot-bellied stove talking about politics, crops, and gossip. Newton Moore was the brother-in-law of powerful Breathitt County sheriff Edward "Ed" Callahan, having married Ed's sister, Julia Ann Callahan, in 1904.

John C. Breckinridge Bellamy was one of the brave Breathitt County boys who marched off to war in 1918 and helped defeat Kaiser Wilhelm of Germany in World War I. The son of Robert and Susan (Bowling) Bellamy, John was known as a crack shot with a Springfield rifle and won numerous shooting medals during his military service.

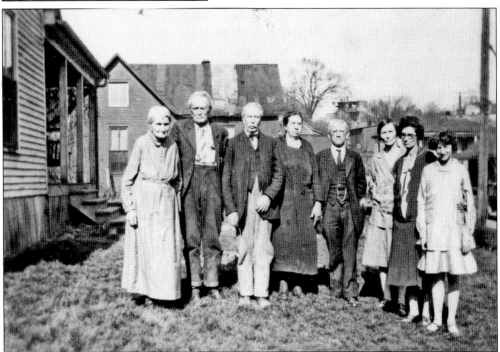

A large group of well-wishers gathered at the home of Jerry Robert and Laura (Hagins) Blake in April 1930 as the two celebrated their 33rd wedding anniversary. Members of the family gathered in the yard of the home for a quick photograph include, from left to right, Maletha J. (Hagins) Landrum, John Linville Hagins, Beriah Magoffin Hagins, Laura (Hagins) Blake, Jerry Robert Blake, Florence Landrum, Margaret (Hagins) O'Mara, and Lena O'Mara.

Pvt. Pearl Neace was a proud veteran of World War II. Born in 1914 to Alexander and Isobelle (Neace) Neace, Pearl married Eurbane Fugate, the daughter of Whick and Eva (Fugate) Fugate on February 14, 1947, shortly after he returned to Troublesome Creek in Breathitt County after his army service. He died on May 17, 1961, and is buried at the McIntosh Cemetery at Clayhole.

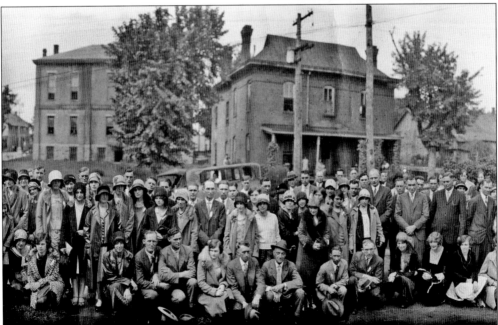

In the late 1920s, members of the Kentucky Education Association and the Upper Kentucky River Education Association gathered on College Avenue in Jackson for a joint conference to discuss the state of education in the mountains. Teachers from across Breathitt County and eastern Kentucky gathered for this photograph before the meeting adjourned. The image, which is a portion of a large 6-foot panoramic view, offers a wonderful view of the Breathitt County Jail and the back side of the Breathitt County Courthouse. The jail was later razed, and a new jail was constructed by the Works Progress Administration in 1940.

George Washington "Bud" Sewell served as the first sergeant of Company D of the 5th Kentucky Volunteer Infantry in the Confederate army during the Civil War. A prominent schoolteacher before the war and the son of the wealthy land speculator John Sewell, Bud was involved in the Masonic lodge, promoting local schools and every aspect of Breathitt County politics after he returned from opposing Sherman's March to the Sea at the close of the war. He died in 1930 and was one of the most widely respected elders in the county at the time of his death.

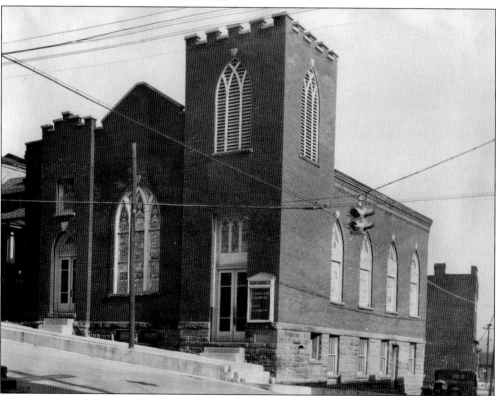

The First Baptist Church of Jackson is located at the corner of Broadway and Main Street and has served the Breathitt County area since 1887. The building was redesigned and rebuilt in 1915 following the destruction of the original building in the 1913 Halloween Night fire, which consumed nearly one-third of Jackson.

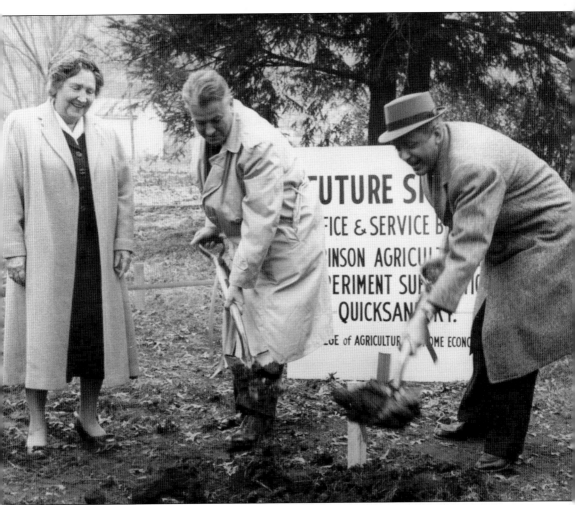

From left to right, Superintendent Marie R. Turner, Kentucky governor Bert T. Combs, and Jackson mayor and businessman J. Phil Smith break ground on the new offices and headquarters building of the Robinson Agricultural Experiment Substation at Quicksand. The new facility was constructed to oversee the operations of the Robinson Forest and the Quicksand station.

The Arrowood School at Canoe in Breathitt County educated thousands of future doctors, lawyers, teachers, and other students who went on to make a difference in eastern Kentucky. The old school was closed after busing and school consolidation was instituted in the 1960s. Over time, the school was neglected, and it no longer exists today.

Reuben Washington Landrum came to the area that became Breathitt County long before the county was formed. He settled on the banks of Troublesome Creek, and there, he and his wife, Margaret (Brashear) Landrum, raised 10 children, including five sons who would fight in the Confederate army. Reuben is buried on the hill at the Strong Cemetery at Lost Creek.

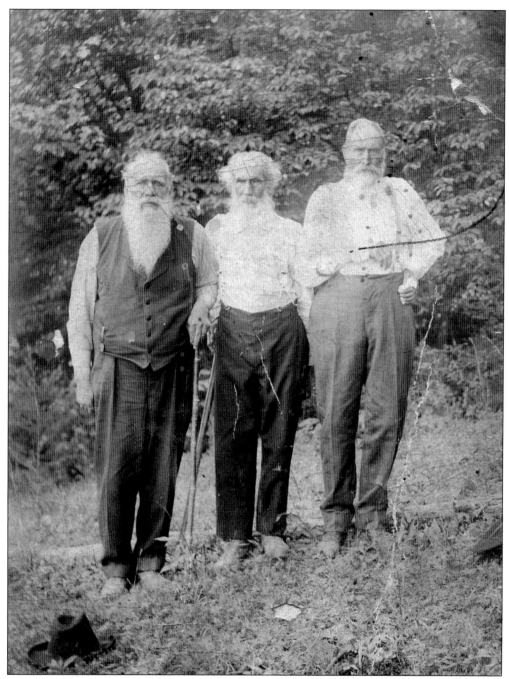
Three of the most prominent men on Quicksand Creek had their photograph taken as they gathered at the Williams Cemetery for a memorial service. From left to right, Rev. C. W. I. Pugh, Gilbert Williams, and Lewis Cecil Back represented three of the most prolific and important families to settle the northeastern section of Breathitt County.

Manford Clemons was proud of his service in the Federal army during the Civil War. As a member of Company D of the 6th Kentucky Cavalry, he was a participant in numerous battles across the state. The son of Franklin and Francis (Miller) Clemons, Manford was born in 1840 and passed away in 1913 at Howard's Creek, where he is buried.

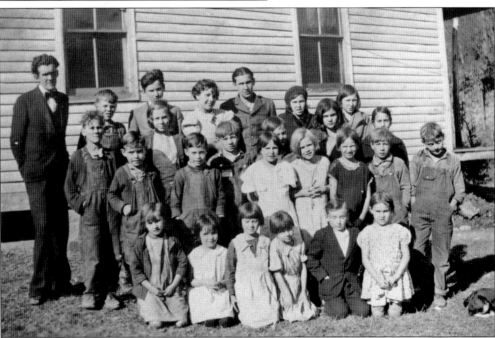

Wardie Craft was a young teacher at the Clear Fork School on Frozen Creek when this photograph was taken in 1933. He worked there for several years and met another teacher, Hazel Back, at the school. Wardie and Hazel were married on June 12, 1938, and raised and provided foster care for more than 100 children over the course of their lives together. Their collection of historical artifacts and materials related to eastern Kentucky history remains at Memory Hill.

With the ringing of the bell at Breathitt High School, students head for the buses parked in the rear of the high school near the campus of Little Red. In the background, notice the tall mountain known as Indian Post Office, which was nearly wiped away by the construction of Highway 15 in the mid-1960s.

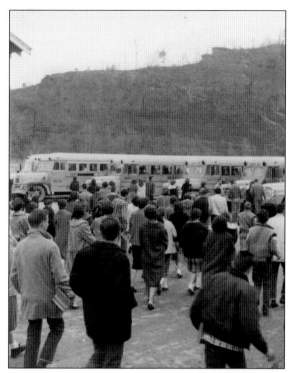

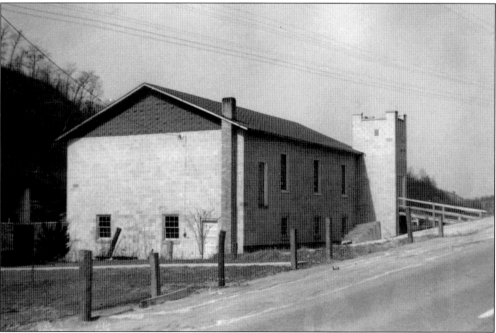

By early 1953, Rev. Walter Strong and the congregation of the First Church of God of Jackson had nearly completed their new church house on Old Quicksand Road near the mouth of Watkins Hollow. The church started in a tent, and Reverend Strong and his followers raised enough money from donations to construct the church, which is still in use by the Happy Church after the First Church of God constructed a new building on Highway 30 West in 2005.

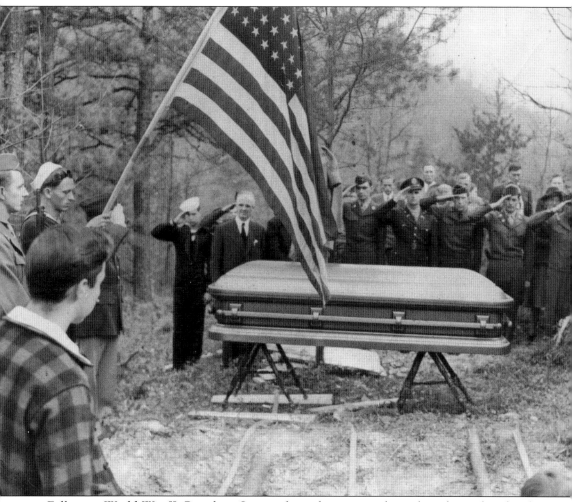

Following World War II, Breathitt County formed its own military burial squad under the command of A. B. Duncan. Its first funeral was conducted in 1946 for Pvt. Alfred Barnett. Members of the military burial squad present for the ceremony were (left to right) Ollie James Sewell, Ed Plummer (holding flag), A. B. Duncan, Rev. Winfred Taylor, Curt Childers, Everett Combs, Garland Wireman, William H. Reynolds, and Carl Plummer. Over the years, the squad helped bury hundreds of Breathitt Countians who were casualties of war.

In April 1960, construction started on the Snow White Clean-O-Matic Launda-mat at the corner of Broadway and Main Street. Construction continued on the structure until it opened on July 1, 1960. The Snow White was open 24 hours a day, seven days a week, and boasted 14 washers and dryers and a state-of-the-art change machine. The concrete block building remains in use today and has been a beauty salon for many years since the Snow White closed. (Both, courtesy of the BCPL.)

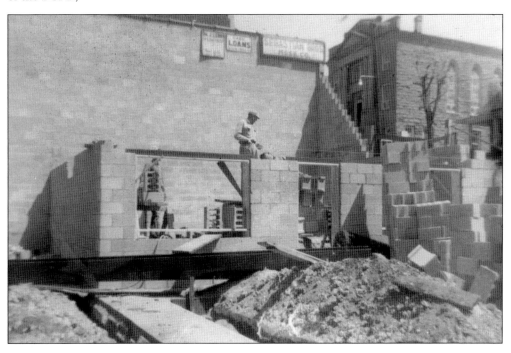

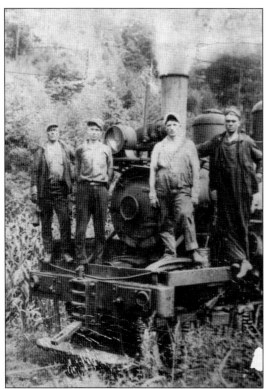

By the mid-1920s, Mowbray and Robinson (M&R) had extended their dinky train lines throughout Breathitt, Perry, and Knott Counties in search of the valuable walnut and other hardwood trees for processing at the Quicksand mill. In 1923, this photograph was taken of the engineers, brakeman, and hands on an M&R dinky steam train as they waited for the crew to unload its haul of timber. At its peak, the Mowbray and Robinson Mill operated 24 hours a day and stopped only for Christmas, Good Friday, Thanksgiving, and Independence Day.

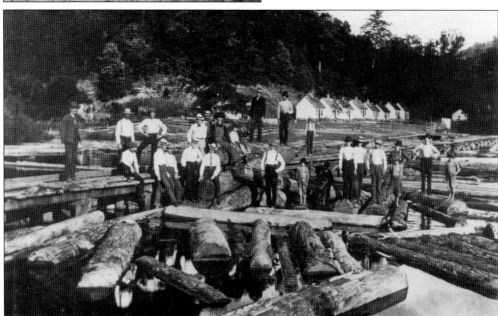

Workers from the Kirk and Kristy (K&K) Lumber and Mill Company facility at Keck on Frozen Creek gathered near the causeway and the splash pond for this picture. The K&K railroad operated a dinky train system that brought harvested logs from the Frozen Creek watershed to the large lumber mill for processing for many years. After the prime timber was harvested, K&K closed its operations on Strong Fork and disassembled the train tracks that lead over Frozen Hill to Jackson.

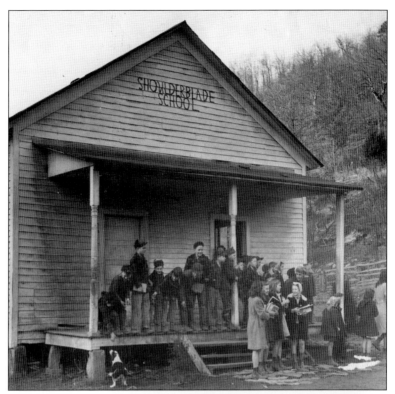

Students prepare to leave for home at the Shoulderblade School after a day of learning and a hot lunch. Shoulderblade was one of the first schools to have an on-site kitchen to provide hot meals for the students as part of the federal school lunch program. The kitchen was built with grant money in the front corner of the school, and a stovepipe was installed for the cook stove.

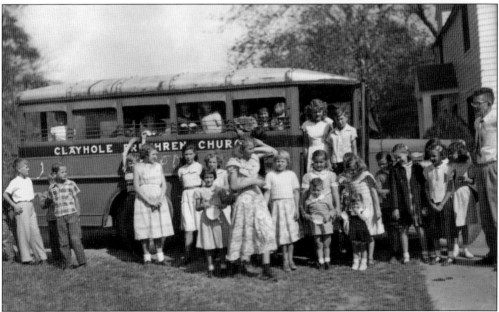

Rev. Sewell Landrum (far right) worked closely with missionaries George and Ada Drushal to establish the Clayhole Brethren Church. Owing to its location on Highway 476, the Clayhole Brethren Church was one of the first churches in Breathitt County to utilize buses to bring churchgoers and Sunday school attendants to the church. Reverend Landrum is seen in this photograph from 1954 with a busload of vacation Bible school attendees.

Prior to the construction of the new main office building, the offices of the State Agricultural Experiment Station at Quicksand were housed in this building, located at the end of the old Mowbray and Robinson Bridge. The well-used structure was torn down when it was replaced with the modern structure, built in 1961 to house both the offices of the substation and the newly created Eastern Kentucky Resources Development Project.

One of the most recognizable sites on the Kentucky and Virginia Highway (now Highway 15 South) was the Quicksand Substation Dairy Barn. Located at the mouth of South Fork near the Blue Bridge, the dairy barn was home to the studies and work of the Quicksand farm. The barn was demolished in the 1960s, when Highway 15 was constructed.

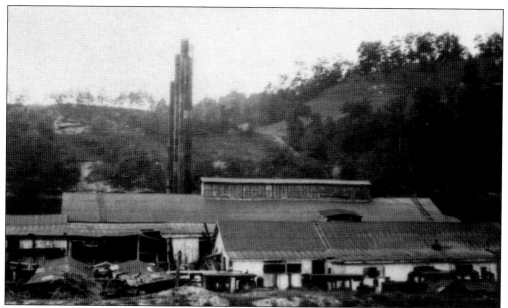

From 1908 until it closed, the planing and stave mill at Quicksand was the world's largest producer of wooden staves, as thousands were produced annually by the workers of Breathitt County. By 1922, the large timber reserves of Breathitt, Knott, and Perry Counties were nearly exhausted, and the stave mill was closed.

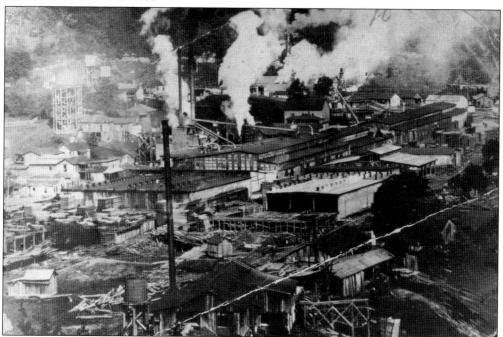

The big mill at the Mowbray and Robinson Lumber Company occupied most of the flat, open fields of the Miles Back farm near the mouth of Quicksand Creek. The mill sat along what is now Wood Center Drive and produced millions of board feet annually for shipment around the world. Much of the lumber produced at this large Quicksand plant was used in the construction of Springfield Armory weapons and by the Singer Sewing Machine Company.

The 1932 graduating class of Jackson City School was the first to wear caps and gowns when it posed on the steps of the high school building. Graduates here, from left to right, are (first row) Mildred Caudill, Helen M. Crawford, Pauline Caudill, and Rosetta Sexton; (second row) Wanda Childers, Nervette Childers, Thelma Reynolds, and Avis Clayton; (third row) Wilburn Eversole, Ollie James Hounshell, Victor Chapman, Wilgus Turner, Miles Griffin, and Walter Sexton. Jackson City School has survived three major fires and continues to educate business, civic, and educational leaders. (Courtesy of the BCPL.)

Members of the 1924 Highland basketball team posed on the steps of the school before a game. Basketball was the pride of the Highland Institute since its founding by Dr. Edward O. Guerrant in May 1907. Highland was known for its fast-paced play and the height of its centers over the years. Fire destroyed the main Highland school building in the 1980s, and the school was consolidated with Turner Elementary to form the Highland-Turner School at Old Buck.

Missionary Dortha Olive Wilson snapped this image as a keepsake of the members of the Morgue Community Church Sunday school. She ventured into the mountains of Breathitt County in 1927 to help teach Sunday school and do mission work in conjunction with the efforts of Lela G. McConnell. After her summer in Breathitt County, she moved back to Ohio and founded a home for unwed mothers in Columbus. She died in California in 1994 but left her photograph album of her trip to the Breathitt County Library for public use. (Courtesy of the BCPL.)

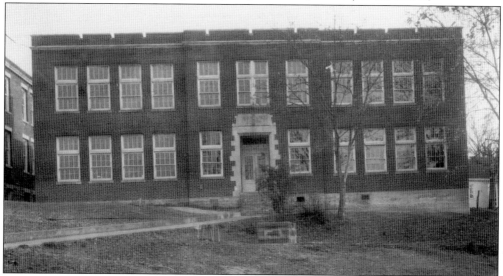

The original Jackson City High School was constructed in 1927 at a cost of $27,000. The new school was necessary due to ever-expanding enrollment at the school following the disillusionment of the cooperative high school contract between the Jackson City school district and the Breathitt County school board. From 1914 to 1918, both schools pooled their money and operated a common high school for the county. In 1918, the arrangement ended, and Jackson City School became the only high school in the county until Breathitt High School opened at Quicksand in 1925. (Courtesy of the BCPL.)

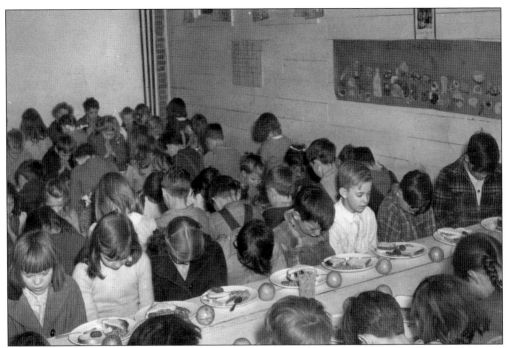

With their heads bowed in thanksgiving, students at Caney Consolidated School on Troublesome Creek in Southeastern Breathitt County prepare to eat a hot meal consisting of a sandwich, beans, and fresh fruit. The school was constructed with federal funds from the WPA in the 1930s and was in continual use until it was merged with Marie Roberts Elementary School. Hailed for its efficient design, the consolidated school replaced several dilapidated one-room schools in the Hardshell community with spacious, well-lit, heated classrooms. Caney employed local teachers and principals who knew the area and parents of the children they served. Caney Consolidated School is a privately owned facility today and occasionally hosts a family or school reunion.

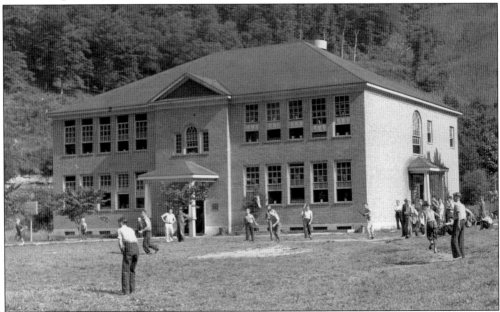

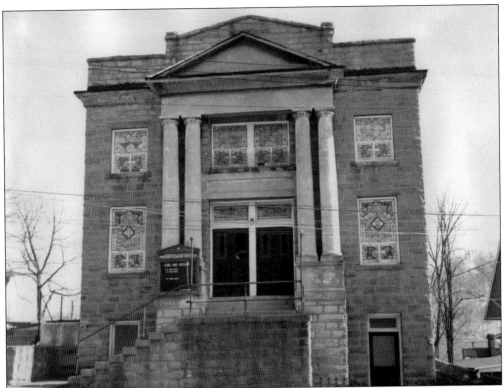

Named for Dr. Edward O. Guerrant, the noted mountain evangelist and missionary, the Guerrant Memorial Presbyterian Church is one of the few remaining buildings in Jackson constructed completely from native sandstone. The new building was founded by Dr. Guerrant and Gen. O. O. Howard during their mission work in the mountains of Breathitt County. The present structure was erected after the original building was consumed by the flames of the Halloween fire in 1913.

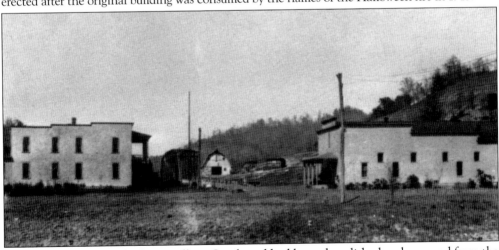

By June 1924, most of the large mills at Quicksand had been demolished and removed from the site. The old Mowbray and Robinson Company offices (left), the dairy barn, and the company store (right) were still standing, and the buildings were used by the Quicksand Substation after E. O. Robinson and Fred Mowbray donated the site and 15,000 acres to the University of Kentucky in 1923.

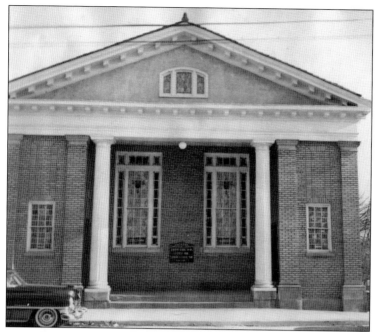

The Jackson Christian Church, located on Academy Street (now College Avenue), dedicated its current church in July 1927. When it was finished, the bright, yellow-brick structure, complete with stained-glass windows, was rivaled only by the Methodist church as the largest church facility in Breathitt County, boasting 12 Sunday school rooms, a large auditorium, a concrete baptistery, a complete modern kitchen, and a large gym in the basement.

Following the closing of the Mowbray and Robinson Lumber Company at Quicksand, the Swann-Day Lumber Company in South Jackson became the largest lumber producer in the county. Specializing in top-grade panel and veneer lumber, like these poplar veneer panels, the Swann-Day company employed more than 600 local people at the peak of its growth. After several years, the unregulated harvesting of walnut and other dense-grade timber had depleted the supply used to produce veneer, and the Swann-Day closed and sold all of its assets.

For years, Edsel S. McCoun owned the service station on Main Street that specialized in servicing both Dodge and Plymouth vehicles. The gas pumps were removed over the years, and the building has served as the home for several businesses, including a print shop and, most recently, an attorney's office. (Courtesy of the BCPL.)

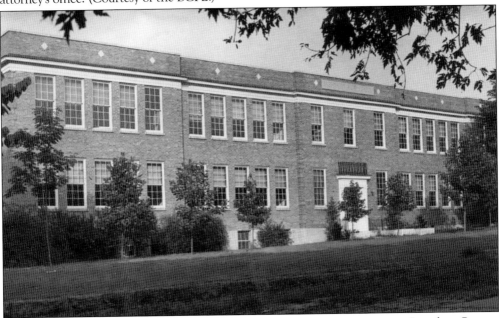

The stately Breathitt High School stood as one of the centers of education in Breathitt County from 1936 until it was razed to make way for the new building, which opened in 1982. The long rows of windows always provided a cool breeze during the summer months and allowed lots of natural light into the building during the winter months. Thousands of leaders in every field passed through its doors.

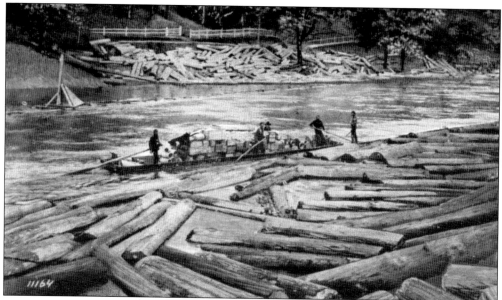

Breathitt County's economy has always been tied to the vast abundance of natural resources that cover and lie under its mountains. Early settlers were drawn to the area because of the large number and size of the oak, walnut, and chestnut trees that grew throughout the area. Large trees were felled and floated down the Kentucky River to Jackson and points beyond. Thousands of Breathitt Countians were employed in the timber industry, and many made a very healthy annual salary through the often dangerous timber industry..

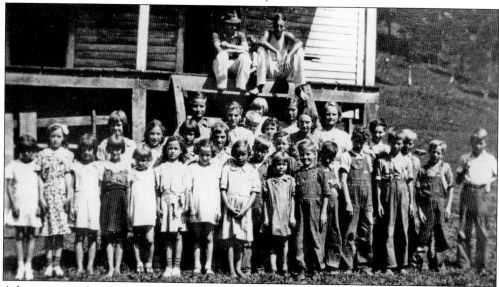

A large group of students stood for this photograph at the Washington School house near the community of Copeland, Kentucky. The school served students from the Lick Branch, Copeland, Little, and Saldee communities in southern Breathitt County until the one-room-school system was consolidated into county schools. At one point, more than 118 schools were in operation across Breathitt County serving the educational needs of generations of students. Over the years, hundreds of lawyers, doctors, legislators, businessmen, and leaders in nearly every industry have been produced by the one-room schoolhouse system.

The campus of Oakdale Christian School looked very different in 1959 than it does today after numerous buildings have been replaced. These views taken from the hillside across Highway 52 and the L&N Railroad tracks show the entire campus. The main office building and the girls' dormitory can be seen in detail above. The school was established on November 1, 1914, by Marion Eason, Elizabeth O'Connor, Mildred E. Norbeck, and Myrtle M. Anderson as the Oakdale Vocational School with the intent of following the plan established by the successful Highland Institute. Eason used her own funds to purchase the original tract of land on which they established the church, a kitchen, and a small frame cottage. Today the school has grown and is educating students from around the world about the importance of a good education and a church-centered life.

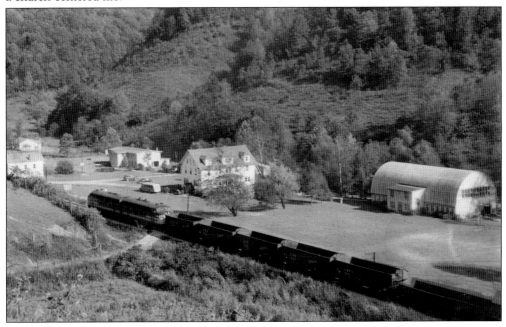

These photographs show a rare view inside one of Jackson's great hotels during its peak in popularity. The lobby of the Hotel Jefferson on Main Street was a bustling place during breakfast and lunch. The hotel boasted the largest and most elegant dining room in the city for many years, complete with real silver and a piano player. The Hotel Jefferson was home to numerous civic organizations that rented the dining room for meetings, including the Kiwanis Club, Rotary Club, Bar Association, and other organizations. The Jefferson was an important social spot for the people of Jackson until improvements to the road system allowed visitors to the mountain to bypass Jackson for accommodations in Hazard and Whitesburg. The dining room at the Jefferson is now the primary meeting and community room for the Breathitt County Life Skills Center.

For years, the Clayhole Brethren Church was the home pulpit for Rev. Sewell S. Landrum, whose travels led him to hundreds of homes and schools during his years of ministry. Reverend Landrum was the host of the annual Sunday school drives that attracted thousands of churchgoers to the Clayhole Church on Highway 476. Many fond memories remain of Reverend Landrum from his years of sleight-of-hand tricks and simple but poignant Bible-based lessons in every county school. Sewell S. Landrum's school ministry ended with his death on May 19, 1984.

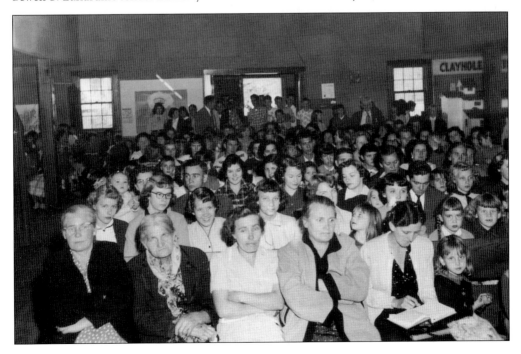

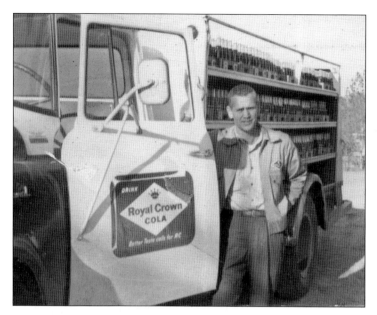

Reliable delivery was one of the trademarks of the Royal Crown Bottling Company in Jackson. The local bottler of Nehi and other soft drinks operated a fleet of trucks delivering RC products across the area. Carl Combs stands proudly by his truck prior to making the Jackson–to–Frozen Creek run. During each visit, deliverymen would drop off new cases of drinks and pick up the returned bottles for refill and redistribution.

Railroad men Wise Deaton (left) and George Kilburn worked to weld a repair in the section of the main L&N track in the long straight stretch in South Jackson. Both men were dedicated, lifelong railroad men. The row of houses that once lined old Quicksand Road can be seen in the background of this photograph.

The most significant period of the history of education in Breathitt County started in 1883, when John J. Dickey's horse stumbled on a rock and came up lame while crossing the Kentucky River near Jackson. Reverend Dickey was on his way to Middlesboro to start a school but was persuaded during his stay here to start his school in Jackson. Lees College and numerous other schools were started by Reverend Dickey, whose influence is still felt in the mountains through his efforts for education.

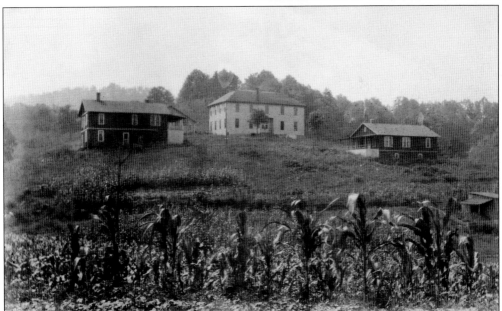

Old Breathitt High School was located at Quicksand for many years. Established in 1925, high school classes were held here for 11 years until 1938, when Breathitt High School moved to Jackson and the building became the Quicksand Grade School. In this 1930 photograph, the old gym can be seen just behind and to the left of the school building in the center. Boys' and girls' dorms were provided for students who lived too far away.

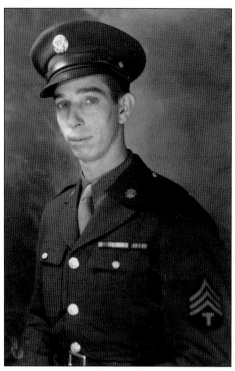

William "Bill" Deaton was born at George's Branch in Breathitt County in 1918, the oldest son of Lewis "Cy" and Nancy Jane (Bellamy) Deaton. He joined the U.S. Merchant Marines during World War II and traveled to most of the countries of South America during his years of service. He also served as a sergeant in the U.S. Army Transportation Corps, and he is pictured here in his army uniform. Proud of his service during the war, he lived most of his life in Hamilton, Ohio, but always called Breathitt County home.

In the early 1950s, construction was started on the new Lost Creek Elementary School near the junction of Highway 476 and Highway 15 South. The school was a consolidated district school that drew students from across the Lost Creek, River Caney, and Haddix communities. The state-of-the-art school was later renamed in honor of longtime Breathitt County Schools superintendent Marie Roberts Turner. Marie Roberts Elementary was later merged with Caney Consolidated.

The Jackson Academy Building at Lees College was funded in 1893 by the people of Jackson with donations from across the country. Designed and constructed by Rev. John J. Dickey and members of the Breathitt County community, the main building of the Lees Collegiate Institute has survived two fires during the years and still serves as the administration building for all Hazard Community College operations in Jackson.

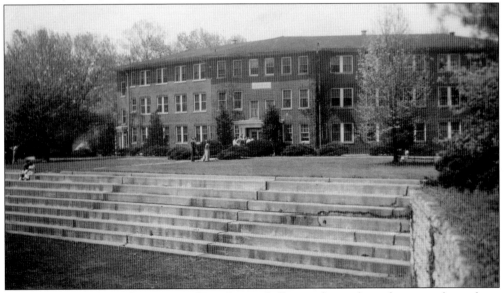

Jackson Hall stands on the campus of Lees Junior College and served as a dormitory for students from around the world. The steps of the amphitheater known as Barclay Stadium can be seen in the foreground. For many years, Barclay was home to the final judging and awards presentations for the annual Kiwanis School Fair and numerous summer baseball games for the children of Jackson.

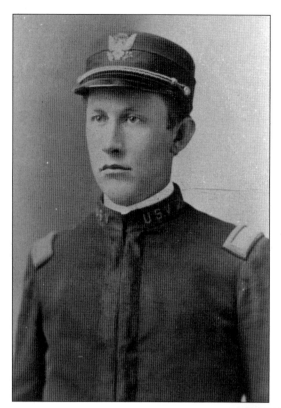

The son of a wealthy and prominent family, Thomas Perrin Cardwell Jr. grew to manhood in the heart of Jackson. His father and mother, Thomas and Ellen (South) Cardwell, represented the elite of Jackson society and power. He joined the U.S. volunteers in the Spanish-American War and later gained a reputation as a fair and honest police judge for the City of Jackson.

On October 24, 1944, Pvt. Joseph G. Watts, son of Joseph and Callie (Deaton) Watts, was killed in the events leading up to the Battle of the Bulge. He was buried in an American military cemetery in Luxembourg. On December 5, 1947, the remains of Private Watts were returned to Kentucky and buried in the Zachary Taylor National Cemetery in Louisville following funeral services in Breathitt County. The family still remembers the death with an annual reunion of the Watts family in July.

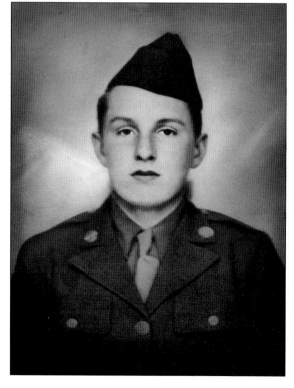

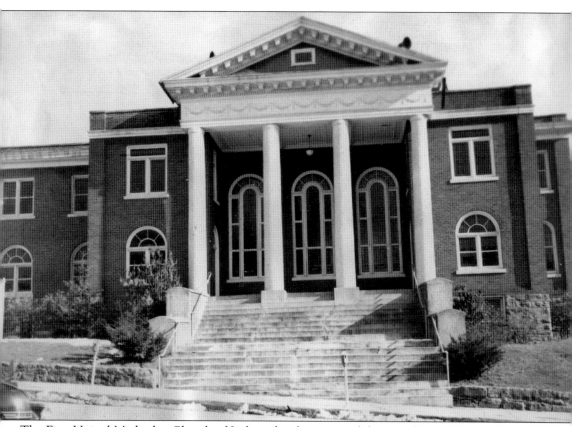

The First United Methodist Church of Jackson has been one of the most beautiful structures in the city of Jackson since it was constructed in 1922 following the destruction of the original church on Court Street. The original church was struck by lightning and burned to the ground in 1916. The congregation purchased the G. W. Sewell boardinghouse and erected this church, which is still in use.

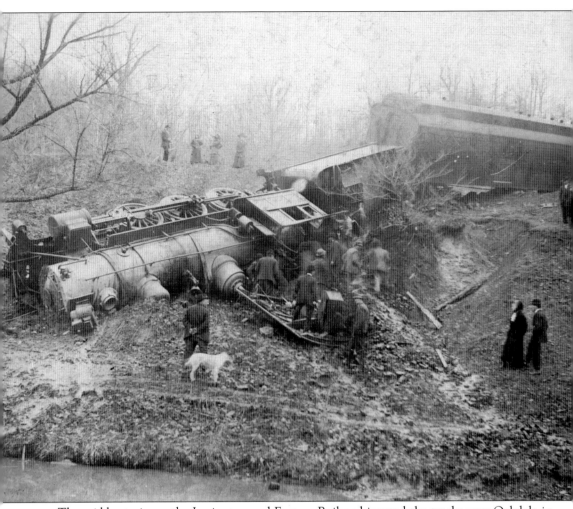

The midday train on the Lexington and Eastern Railroad jumped the tracks near Oakdale in January 1912, despite the best efforts of its crew. Engineer James Clark and Fireman Clarence Vance were both slightly injured in the wreck, but they managed to keep the loaded passenger cars from overturning. Engine No. 9 was severely damaged but was repaired and returned to service a few months later.

Index

Athol, 46
Barclay Stadium, 15, 123
Breathitt County Courthouse, 13, 20, 31, 97
Breathitt County Jail, 92, 97
Breathitt County Public Library, 35, 68
Breathitt High School, 19, 20, 40, 52, 60, 121
Breathitt Masonic Lodge No. 649, 22, 44, 71
Broadway, 27, 30, 71, 89, 95, 98, 105
Buckhorn Creek, 85
Callahan, Edward "Ed," 18, 76, 95
Canoe, 38, 65, 90, 100
Clayhole, 61, 97, 107, 119
College Avenue, 15, 27, 30, 35, 54, 57, 72, 114
Copeland, 116
Court Street, 20, 23, 31, 71, 92, 124
Day Brothers, 14, 93
Devil's Backbone, 16
Evanston, 39
Frog Pond, 10, 16
Frozen Creek, 21, 27, 78, 80, 92, 102, 106, 120
Haddix, 122
Hardshell, 55
Hargis, James Henderson, 18, 20, 23, 42, 76
Highland Avenue, 17, 45, 48
Hotel Jefferson, 24, 69, 118
Hurst Lane, 45, 48, 54, 80, 83
Jackson City School, 15, 74, 94, 110
Jackson Woman's Club, 64
Kentucky River, 21, 25, 30, 32, 82, 116
Leatherwood Creek, 49, 79
Lee College, 12, 15, 41, 56, 57, 66, 78, 121, 123
Lexington and Eastern Railroad (L&E), 22, 33, 126
Little, 116
Little's Creek, 26, 69
Lost Creek, 47, 63, 100, 122
Louisville and Nashville Railroad (L&N), 33, 52, 66, 70, 81, 117, 120
Main Street, 20, 23, 26, 33, 42, 43, 60, 98, 105, 115, 118
Marcum Heights, 84
McConnell, Lela G., 36, 59, 70
Mount Carmel, 34, 36
Old Buck, 110
Olean Chemical Company, 35
Panbowl (Panhandle), 30, 31, 55
Quicksand, 24, 32, 40, 61, 63, 67, 73, 83, 84, 99, 101, 103, 106, 108, 109, 111, 113, 121
River Caney, 46, 122
Saldee, 116
South Fork, 78, 51, 108
South Jackson, 16, 27, 54, 70, 74, 90, 93
Swann-Day Lumber Company, 10, 16, 34, 114
Troublesome Creek, 97, 112
Turner's Creek, 39
Watts, Kentucky, 49, 79
White Oak, 62

www.arcadiapublishing.com

Discover books about the town where you grew up, the cities where your friends and families live, the town where your parents met, or even that retirement spot you've been dreaming about. Our Web site provides history lovers with exclusive deals, advanced notification about new titles, e-mail alerts of author events, and much more.

MADE IN THE USA

Arcadia Publishing, the leading local history publisher in the United States, is committed to making history accessible and meaningful through publishing books that celebrate and preserve the heritage of America's people and places. Consistent with our mission to preserve history on a local level, this book was printed in South Carolina on American-made paper and manufactured entirely in the United States.

This book carries the accredited Forest Stewardship Council (FSC) label and is printed on 100 percent FSC-certified paper. Products carrying the FSC label are independently certified to assure consumers that they come from forests that are managed to meet the social, economic, and ecological needs of present and future generations.

FSC
Mixed Sources
Product group from well-managed forests and other controlled sources

Cert no. SW-COC-001530
www.fsc.org
© 1996 Forest Stewardship Council

Find Your Place in History.